Capturing Beauty

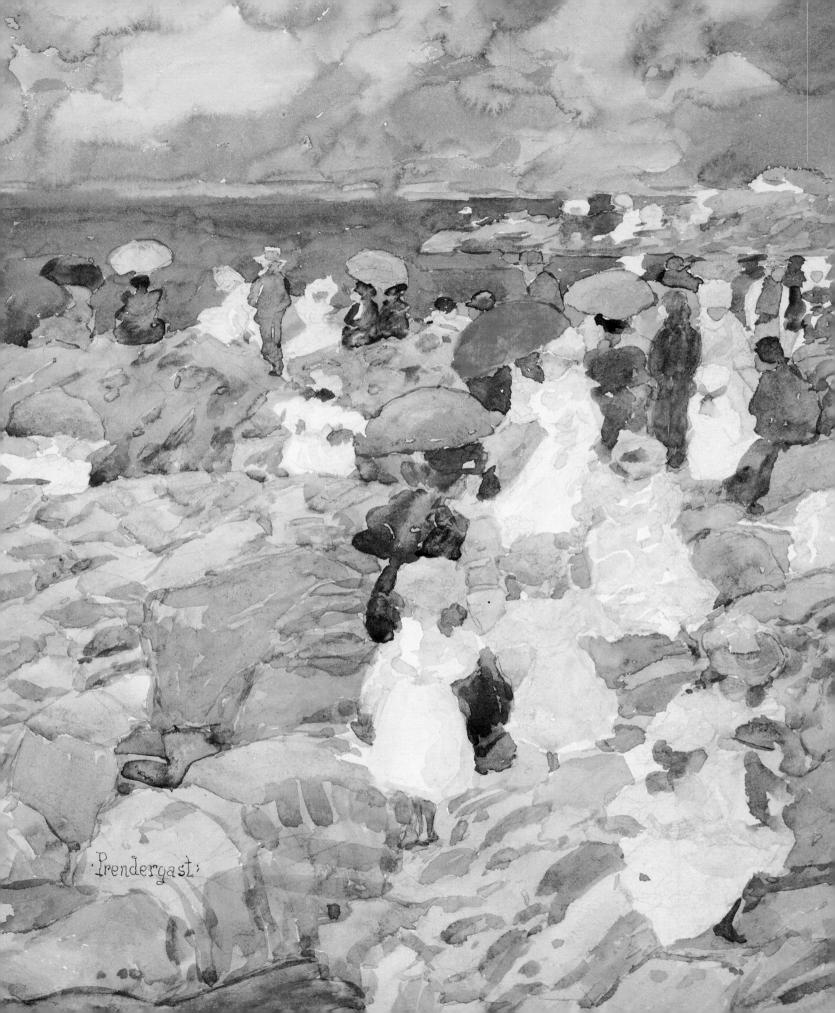

Capturing Beauty

American Impressionist & Realist Paintings
from the McGlothlin Collection

by David Park Curry

Introduction by Theodore E. Stebbins, Jr.

VMFA

Virginia Museum of Fine Arts

Distributed by the University of Virginia Press

This catalogue was published on the occasion of the exhibition *Capturing Beauty: American Impressionist & Realist Paintings from the McGlothlin Collection,* May 19 – September 18, 2005.

Organized by VMFA, the exhibition was made possible by the Elisabeth Shelton Gottwald Fund and the Lettie Pate Whitehead Evans Fund.

The catalogue was made possible by the Julia Louise Reynolds Fund.

Cataloging information is available from the Library of Congress.

ISBN 0-917046-78-1
Printed in the United States of America

Produced by the Office of Publications
Virginia Museum of Fine Arts
200 N. Boulevard, Richmond, Virginia 23220-4007
DISTRIBUTOR: University of Virginia Press, Charlottesville
EDITOR: Rosalie West
DESIGNER: Sarah Lavicka
PHOTOGRAPHY CREDITS: For photographs on pp. v, 24, 28, 42, 48, 54, 56, 58, 60, 62, 66, 68, and 70, we thank Michael Altman Fine Arts; Berry-Hill Galleries; Museum of Fine Arts, Boston; and Mr. and Mrs. James McGlothlin. All other photographs were taken by Katherine Wetzel.
COMPOSITION: Garamond 3 in QuarkXpress by the designer
PRINTING: On acid-free 100 lb Sappi McCoy Matte text by Progress Printing, Richmond.

FRONT COVER: John Singer Sargent, *Madame Errazuriz,* ca. 1883–84, detail (see p. 12); FRONTISPIECE: Maurice Brazil Prendergast, *Handkerchief Point,* ca. 1896–97, detail (see p. 36); DIVIDER PAGES: p. v, Martin Johnson Heade, *Two Magnolias and a Bud on Teal Velvet,* ca. 1885–95, detail (see p. 28); p. vii, Childe Hassam, *Winter Nightfall in the City,* 1889, detail (see p. 26); p. x, William Merritt Chase, *Afternoon by the Sea,* ca. 1888, detail (see p. 20); p. 1, Everett Shinn, *Back Row, Folies-Bergère,* 1900, detail (see p. 46); p. 71, William McGregor Paxton, *The Letter,* 1908, detail (see p. 56); BACK COVER: Robert Henri, *The Sketchers,* 1918 (see. p. 66).

Contents

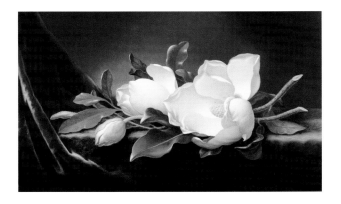

Foreword

The title *Capturing Beauty* applies to the creative process of the gifted artists represented in this catalogue. It also aptly describes the enterprise of Fran and Jim McGlothlin as they put together their extraordinary collection of American art. For almost a decade, they have traveled, studied, and carefully selected some of the finest examples of nineteenth- and twentieth-century American art.

The distinctive quality of the McGlothlin collection —introduced here by their friend, noted scholar Dr. Theodore E. Stebbins, Jr., Curator of American Art at the Fogg Art Museum of Harvard University, —comes from a keen aesthetic sensibility combined with a passion for American art. The collectors have been rewarded by their instincts. For example, Childe Hassam's *Winter Nightfall in the City* (see opposite detail and p. 27) was not eagerly sought by the New York art market when it appeared at auction in 2000. Nevertheless, Jim and Fran bid on the painting. After they succeeded in purchasing the canvas and had it cleaned, a wondrous example of Hassam's Parisian work was revealed for us all to enjoy.

For this special showing, the McGlothlins generously permitted the Virginia Museum of Fine Arts to exhibit a group of works from their private holdings. We appreciate the difficult decision they made in allowing favorite pieces to leave their home for several months. In turn, the Museum faced the happy challenge of choosing from so many outstanding works. In focusing on the dynamic decades bridging the turn of the twentieth century, we present thirty-three Impressionist and Realist oils, watercolors, and pastels, along with two splendid bronzes.

Capturing Beauty complements the VMFA collection of American art in many ways. The McGlothlin collection presents sterling examples created by artists not yet represented at VMFA, while also providing a more comprehensive understanding of artists whose works we have in common. Museum visitors will have the pleasure of examining oils by Bunker, Paxton, Robinson, Twachtman, and others—works VMFA currently lacks. At the same time, encountering Robert Blum's pastel of his model and love-interest, *Flora de Stephano* (see p. 31), we realize that the Museum's own Blum, an oil entitled *Temple of Fudo Sama at Meguro, Tokyo,* once belonged to that radiant beauty. And Childe Hassam's *Moonlight* (see p. 55) resonates with another closely related canvas, VMFA's *The Isles of Shoals.* In providing these exciting links and more, *Capturing Beauty* helps us to celebrate VMFA's American collection once again before the galleries close this fall in preparation for our major expansion project.

VMFA is extremely grateful to the Julia Louise Reynolds Fund for the underwriting of this catalogue. I thank Dr. David Park Curry, Curator of American Arts at VMFA, for his discussions of individual works, and Dr. Stebbins for his introduction; together they have produced an engaging and informative text that enriches our experience of this important collection. Rosalie West and Sarah Lavicka are to be congratulated as editor and designer of this beautiful publication. The accompanying exhibition was generously funded by the Elisabeth Shelton Gottwald Fund and the Lettie Pate Whitehead Evans Fund.

Dr. Michael Brand
Director

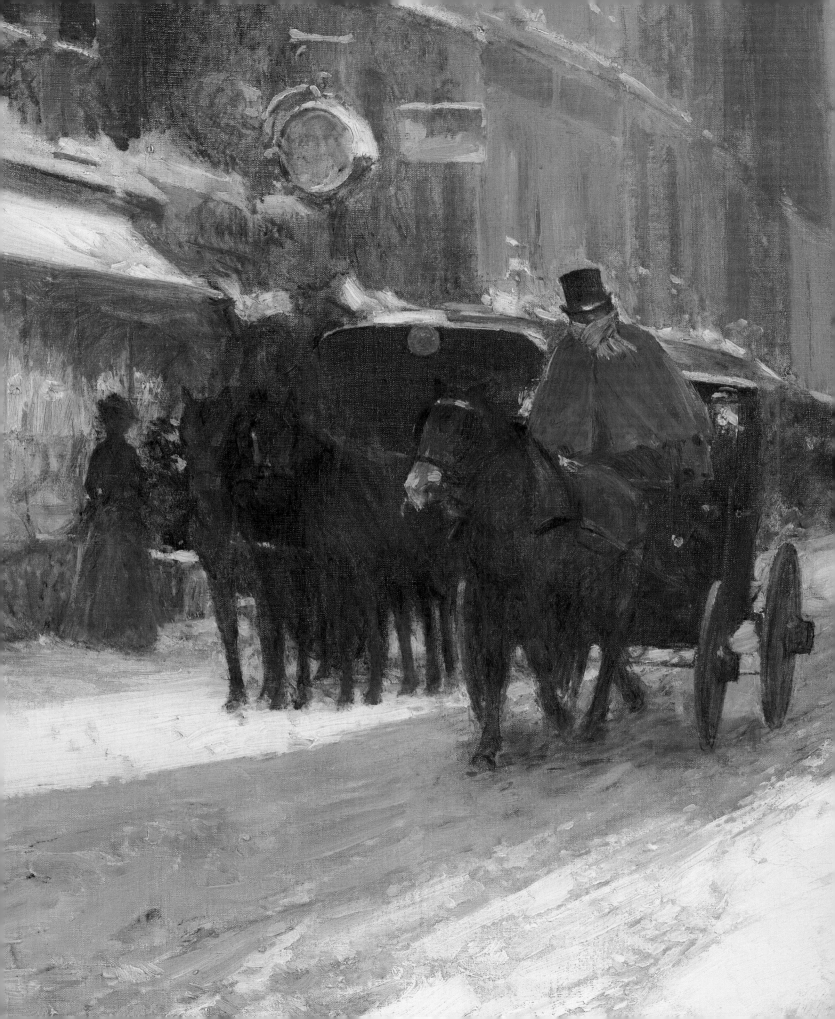

Acknowledgements

I became acquainted with the McGlothlin collection in 2000, not long after Fran became a VMFA trustee. As the present catalogue and exhibition demonstrate, this was a most auspicious beginning for a new century of exploring American art at VMFA. While I was aware that the McGlothlins had been actively expanding and refining their holdings, it was a very pleasant surprise indeed to learn how many works of the first quality had entered their collection in only a few years. When they made the public-spirited decision to exhibit some of their favorite pictures for the benefit of the Commonwealth and its visitors, the Museum was given full access to the paintings, and I was encouraged to choose from among the finest examples of all. I am profoundly grateful to Fran and Jim for the opportunity to spend time with such exquisite works of art.

Our selection process was greatly aided by Dr. Theodore E. Stebbins, Jr. A productive scholar from the first generation of serious Americanists, he is presently Curator of American Art at the Fogg Art Museum, Harvard University. Ted's many credits include a stint as a professor in the History of Art department at Yale University, where he greatly enriched my understanding of American art during my studies there. Some of his ideas echo through these pages, and the Museum is delighted that the catalogue begins with his insightful overview, placing the McGlothlin collection in a larger context of American patronage and art history.

Many other dedicated people both inside and outside the Museum shared their talents and expertise to make the idea of *Capturing Beauty* a reality. Here at VMFA, Dr. Elizabeth O'Leary, Associate Curator of

American Arts, worked tirelessly to assemble research files on individual pieces, generously contributing her time, organizational abilities, writing skills, and deep knowledge of American art and culture to help ensure that the entire project— from catalogue research to label copy to public programming—flowed steadily through the thicket of deadlines. The project could never have been completed without her unstinting support, and I am ever in her debt.

Dr. Suzanne Freeman, Head Fine Arts Librarian, and archivist Courtney Yevich solved my endless research queries—no matter how arcane—with dispatch, precision, and good cheer. Working at amazing speed and with consummate skill, Chief Collections Photographer Katherine Wetzel captured two-thirds of the chosen artworks in beautiful new photography. Susie Rock, Coordinator of Photography, and Howell Perkins, Manager of Photographic Resources, dealt with our image needs. Editor in Chief Rosalie West edited the catalogue manuscript with her usual tactful perspicacity, while Chief Graphic Designer Sarah Lavicka swiftly created an elegant publication befitting the compelling works within. Anne Adkins created the catalogue index. For the exhibition, Lucy Grey skillfully edited the labels as well as the publicity materials that were handsomely designed by Jean Kane. Lee Anne Hurt, Assistant to the Director, served as interdepartmental project liaison, keeping information channels open in all directions. The imperturbable Mary Sullivan, Associate Registrar, gracefully shepherded the packing and shipping of artworks from various locales. Connie Morris, curatorial executive secretary, handled complicated scheduling and travel details. With his customary

eye for nuance and detail, exhibition designer Tom Baker conceived the beautiful galleries in which the collection is presented. Lighting designer Mary Brogan orchestrated the sensitive exhibition lighting, bringing bold oils and delicate works on paper into harmonious balance. Kathryn DeHaven James expertly designed and produced the labels. I am also grateful to Aiesha Halstead, Coordinator of Exhibition Planning, and the VMFA exhibition design and production staff.

I thank a number of New York firms, particularly Michael Altman Fine Art. Michael and his associate Kate Lester extended many a professional courtesy, helping us to view individual works of art, obtain elusive photographs, garner frame measurements, and centralize shipping arrangements. Elisabeth Oustinoff at the Adelson Galleries kindly helped with information on Sargent. Dr. Bruce Weber at the Berry-Hill Galleries explained issues of facture in the work of Robert Blum. Susan Menconi of the Menconi-Schoelkopf Gallery clarified questions about sculptor Adolph Weinman. Brad Shar at Julius Lowy Frame & Restoring Company facilitated my review of paintings that were being rehoused in period-style frames.

Elsewhere, I am grateful to Pat Lynaugh of the Smithsonian American Art Museum/National Portrait Gallery Library in Washingon, D.C.; Margaret Southwick at the Lora M. Robins Library, Lewis Ginter Botanical Garden, Richmond; Matthew Mangold and Betsy White at the William King Regional Art Center, Abingdon, Virginia; and Dennis Kiel at the Cincinnati Art Museum. The staff of the Naples Art Museum shared photographic equipment with us during our whirlwind photo shoot in Florida. And for sharing her file information, we offer special thanks to Tracy Pierce at the United Company.

The text of the catalogue rests on the work of several generations of American art scholars. We gratefully acknowledge their important contributions to the field in our "Bookshelf" section. Ultimately, American collectors, scholars, and museum visitors treasure works of art such as those in the McGlothlin collection not only for the aesthetic beauty they capture, but also for the welter of ideas they preserve. The American Impressionist and Realist pictures in the exhibition invite repeated discovery.

Dr. David Park Curry
Curator of American Arts

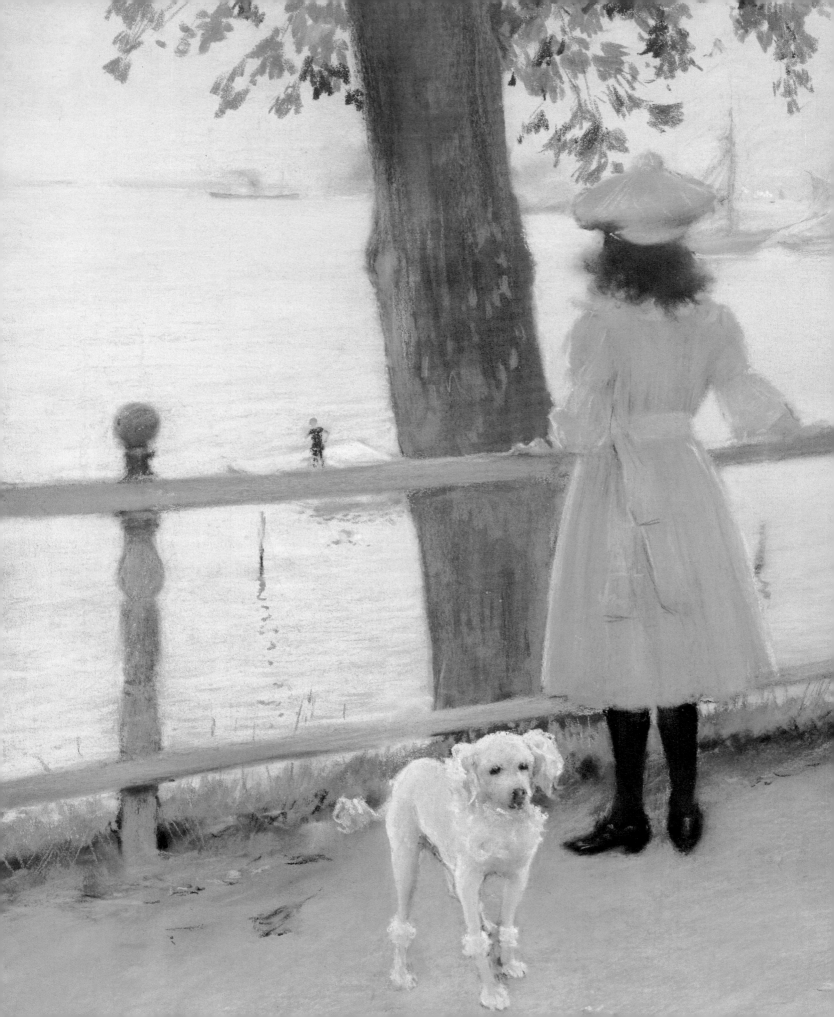

Introduction

In just over eight years, James and Frances McGlothlin have formed one of the nation's finest private collections of nineteenth- and twentieth-century American painting. Soon after they met, Jim and Fran discovered a mutual interest in art, and they quickly joined a small group of eight or ten collectors across the nation who pursue American art at the highest level.

In December 1996 the McGlothlins demonstrated their seriousness of purpose when they purchased the painting by John Singer Sargent entitled *Gathering Blossoms, Valdemosa* (see p. 59). This represented an adventurous choice on their part: the Sargent is sensuous and sunlit, but it also is a subtle, complex work. One sees yellow foliage at the top of the composition and two half-hidden, cropped figures at the bottom, the whole unified by the strong diagonals created by rocks and roots. It is a work that rewards study and reveals its qualities slowly. In buying it, Jim and Fran set the standard for their collection: they would aim for the best and not be afraid to compete for the work of the most admired American painters. This purchase also told us that their collection would not shy away from difficult paintings, that they prefer meaningful, serious works of art to merely pleasant ones. In terms of its subject, the Sargent also set the stage for other challenging works that would follow it into the collection, including the mournfully beautiful Mary Cassatt, *Lydia Seated on a Terrace, Crocheting* (see p. 9) — another composition in which one hardly notices the figure at first — and the brilliant pastel by William Merritt Chase entitled *Afternoon by the Sea* (opposite and p. 21), in which a central figure has her back to us.

The McGlothlin collection includes examples of almost every member of what was arguably the "greatest generation" of American painters. Winslow Homer, the most powerful of nineteenth-century Realists, is richly represented here, as is the great triumvirate of expatriates, Sargent, Whistler, and Cassatt. Also included are the leading figures of American Impressionism, Chase and Hassam; the best of the more conservative Boston painters, Bunker and Paxton; the subtlest Post-Impressionists, Prendergast and Twachtman; and three leading members of the "Ashcan School," Henri, Sloan, and Shinn, along with their contemporary, George Bellows. Yet this is not a collection of names. Judging from what we see in this catalogue, these collectors buy what moves and pleases them without regard to who painted it. They take as much interest in the works of painters known only to specialists — such as Julius Stewart, Seymour Guy, or Robert Blum — as in those of the great masters. Their taste is broad: they also appreciate and collect American genre and landscape painting, though they have not bought many still lifes except for a beautiful group by Martin Johnson Heade (see pp. 25 and 29).[1] Almost a third of this exhibition consists of works on paper; the brilliant watercolors by Homer and Sargent, and the amazing pastels by Chase and Blum, demonstrate the artists' highest achievement in these mediums. It should be added that the McGlothlins consider the collection very much a work in process, and one looks forward with keen anticipation to see where their interests take them next.

In the past forty years, two major changes have occurred in the field of American art. First, there has been a huge boom of interest in art and museums

in general, and especially in American art. In 1965 only a handful of museums had curators in the American area, and even fewer colleges and universities taught the field regularly; there were only a few dealers in New York, Boston, and Philadelphia handling American paintings, and hardly more than a dozen private collectors were seriously engaged in pursuing them. All this has changed dramatically. Today well over a hundred museums in every corner of the nation possess worthwhile collections, hundreds of academic institutions teach the field, and a plethora of dealers, auction houses, advisers, consultants, and "runners" serve an ever-growing population of collectors. American art of high quality can be found on permanent view in France, Spain, and England, while universities across Europe teach the subject; recently important exhibitions have traveled to several European nations as well as Mexico, China, and Japan. It can no longer be said that American art is unknown or underrated.

The second revolutionary change has been one of taste. Today we rank the various artists and schools far differently than we did forty years ago. From the 1920s through the 1950s early American portraiture and history painting, along with what was then considered the major trio of native-born "independents," Homer, Eakins, and Ryder, were most highly valued. The new taste, beginning around 1960, continued to value Homer and Eakins very highly but now brought into the canon the leading landscape, still-life, and genre painters, especially the so-called "luminists," Martin Johnson Heade and Fitz Hugh Lane. The great Boston collector Maxim Karolik had pioneered this view during the 1940s. Influenced by the presence of the Karolik Collection at the Museum

of Fine Arts, a young generation of Harvard-trained scholars—including John Wilmerding, Barbara Novak, and myself—set out to discover more about Karolik's favorite painters and to give them their rightful place in history.

At that time the American expatriates, Impressionists, and even the early-twentieth-century Realists were regarded as having only minor importance. In 1963 Edgar P. Richardson, perhaps the leading historian of the period, wrote in reference to Cassatt, Sargent, Whistler, and the others that "the cosmopolitan movement . . . dwindles in the perspective of time."[2] Sargent was considered superficial in comparison to the profundity of Eakins; Richardson found his work and that of the others who had studied in Paris "an exercise in taste and talent rather than a vehicle for creative passion and power." Regarding Bellows, now seen as one of the greatest painters of his generation, Richardson opined that "time has not sustained Bellows' contemporary fame" and concluded that his work "seems now faded and, worse still, mediocre." Richardson was not foolish, and in fact he represents his period well; what we learn is that taste in art (and everything else) is inevitably cyclical. Thus, today's art world sees things very differently. Of the trio of "native" painters, only Homer has been consistently admired from his lifetime to the present; Eakins's reputation seems to have diminished somewhat, while Ryder has practically disappeared. At the same time, the expatriate trio has risen to dominance both in the marketplace and for museums and scholars. Whistler and Cassatt are greatly esteemed today, and Sargent is now universally admired for his extraordinary touch with both oil paint and watercolor, and for his ability

to evoke light and mood on one hand, and character and status on the other.

With the rise of the expatriates has also come a virtual revolution in the way we look at such contemporaries as Chase, Robinson, Twachtman, and the other Impressionists who after training in Europe returned to live in this country. Scholars embarked on a new mission: giving up the search for what is most "American" about American art, they began to examine American art in its international context. In doing so, the old prejudice against American painters who were trained in Europe, or who even lived their whole lives abroad, disappeared.

As William H. Gerdts has written, "the heyday of Impressionism in America ran for roughly thirty years, from about 1885 to 1915, followed by fifty years of neglect and disfavor."[3] Beginning in the early 1960s, two collecting couples in New York who were close friends, Margaret and Raymond Horowitz and Rita and Daniel Fraad, pioneered the revival of turn-of-the century painting, and particularly of Impressionism. The dealers, and eventually the scholars and museums, picked up on the new taste: the Brooklyn Museum in 1964 showed the Fraad Collection, and the Metropolitan Museum of Art in 1973 exhibited the Horowitz holdings. Useful scholarly catalogues accompanied both. Two groundbreaking surveys of American Impressionism followed, by Donaldson Hoopes in 1972 and Richard Boyle two years later. William H. Gerdts then took up the cause in 1980, organizing for the Henry Art Gallery at the University of Washington an exhibition of American Impressionism that has rarely been equaled, and writing for its catalogue

a thoroughly researched, persuasive analysis of the movement. That the show's tour was limited to four small museums from Los Angeles to Boston is further indication that general appreciation of this area of American art was still in a nascent phase. Gerdts then produced his big, still definitive *American Impressionism* in 1984, and—coincidentally or not—the boom began as collectors including Daniel J. Terra and Richard A. Manoogian drove prices higher and higher; scholars such as Richard Ormond, David Park Curry, Barbara Weinberg, Nancy Matthews, and many others produced ever more informative studies; and museums across the country, along with a number of dealers, mounted impressive exhibitions.

The McGlothlins are indebted to those who have gone before, and they are particularly aware of the examples set by the Horowitzes and the Fraads both as collectors and as citizens of the art world. The subtitle of the present exhibition and catalogue, *American Impressionist & Realist Paintings from the McGlothlin Collection,* pays homage to the title of the 1973 Horowitz exhibition at the Met, which employed the same terms. In addition, the McGlothlin's admiration for the Fraads was made manifest when they aquired three works at the Fraad Sale at Sothebys in December 2004: these include Twachtman's wonderful *Gloucester, Fishermen's Houses* (see p. 43); Robert Henri's pastel, *The Sketchers* (see p. 67); and John Sloan's evocative *Gray Day, Jersey Coast* (see p. 63). If any earlier collection serves the McGlothlins as a model, it is surely that of Mr. and Mrs. Fraad, for they share that couple's great admiration for both Homer and Sargent; their interest in the unsentimental side of Impressionism and in the

later Realists including Henri, Sloan, and Shinn; their appreciation of works on paper; and the high standard of quality to which they aspire.

In examining the three Fraad-McGlothlin paintings mentioned above, and indeed when considering the whole of the McGlothlin collection, one comes to realize the limitations of traditional terminology and especially of the basic terms "Impressionism" and "Realism." In about 1900 one of the archetypal Impressionists, John H. Twachtman, painted an unsentimental view of some shacks belonging to poor fishermen, a subject one would normally expect from Robert Henri and the Ashcan School. Henri, for his part, was a key founder of tough-minded Realism in this country, but in his brilliant pastel of 1918, one of the latest works in this catalogue, he returned temporarily to a quickly brushed Impressionist style. Finally, John Sloan painted *Gray Day, Jersey Coast* in 1911 at the height of his powers, just five years after he had several works returned from an exhibition as "too vulgar," and in the same period he was making his most telling social commentary in such paintings as *The Haymarket* (1907), *McSorley's Bar* (1912), and *Sunday, Women Drying Their Hair* (1912).[4] Yet *Gray Day*—which he called his "first attempt at such a subject"—is more picturesque than probing, and what one carries away from it is an old fashioned sense of the cool, stormy atmosphere created by a painter with facile, nearly Impressionist, brushwork. To suggest other examples, in this exhibition we see Sargent working on one painting in an Impressionist mode, as noted above, but in another, *Venetian Wineshop* (see p. 39), creating a Realist picture that Robert Henri would have admired. In his *Winter Nightfall in the City*

(see p. 27) we find Childe Hassam, perhaps the most stylistically pure of the American Impressionists, doing a gritty urban night scene that seems as much Realist as it is Impressionist. Finally, we recall that Winslow Homer, long regarded as the quintessential Realist, was invited to join the "Ten American Painters," the core group of American Impressionists, when it was founded in 1897. Though Homer declined, the invitation demonstrates again the relative unity of American painters, and American style, in the period.

Thus it appears that Impressionism and Realism in the McGlothlin collection, and indeed in nineteenth- and twentieth-century American painting in general, should not be read as describing two separate, discrete approaches, one following the other, but rather as imprecise terms that describe aspects of many paintings of the period. As Barbara Weinberg and her colleagues noted, few painters of any description attempted to depict the real problems of modern American life in the years 1885–1915.[5] This was an era of economic unrest, political corruption, and dramatic social change, but the painters portrayed the genteel, peaceful world that their patrons believed in, with even the Ashcan painters rarely going beyond modest renderings of the picturesque but unthreatening poor. Realist and Impressionist painters alike depicted scenes that one might find described in the writings of Henry James and Edith Wharton, rather than the harsher, more psychologically probing Realism found in the fiction of Theodore Dreiser or Stephen Crane. As we have seen, most of the paintings in this exhibition— excepting those by Martin Johnson Heade, perhaps— make use of some elements of both Impressionism

and Realism. In the end, terminology is insignificant. What matters most is that we recognize the gifts of this great generation of American painters, and glory in the evocative beauty of their work.

Dr. Theodore E. Stebbins, Jr.

1. A selection of twenty-six paintings from the McGlothlin Collection, including a number of landscapes, was exhibited in early 2005. See Matthew Mangold, *An American Perspective: Paintings from the New World, 1820–1930* (Abingdon, Va., 2005).

2. Edgar P. Richardson, *A Short History of Painting in America: The Story of 450 Years* (New York, 1963), 201, 257.

3. William H. Gerdts and David Dearinger, *Masterworks of American Impressionism from the The Pfeil Collection* (Alexandria, Va., 1992). See also Gerdts, *American Impressionism* (Seattle, Wa., 1980) and Gerdts, *American Impressionism* (New York, 1984; second edition 2001, with two added chapters).

4. These works are, respectively, in the collections of the Brooklyn Museum, the Detroit Institute of Arts, and the Addison Gallery of American Art.

5. See Barbara Weinberg, Doreen Bolger, and David Park Curry, *American Impressionism and Realism: The Painting of Modern Life, 1885–1915* (New York, 1994).

The question of development of the art spirit in all walks of life interests me.

I mean by this, the development of individual judgment and taste. . . .

If anything can be done to bring the public to a greater consciousness of the

relation between art and life, of the part each person plays by exercising

and developing his own personal taste and judgment . . . it would be well.

— Robert Henri, 1916

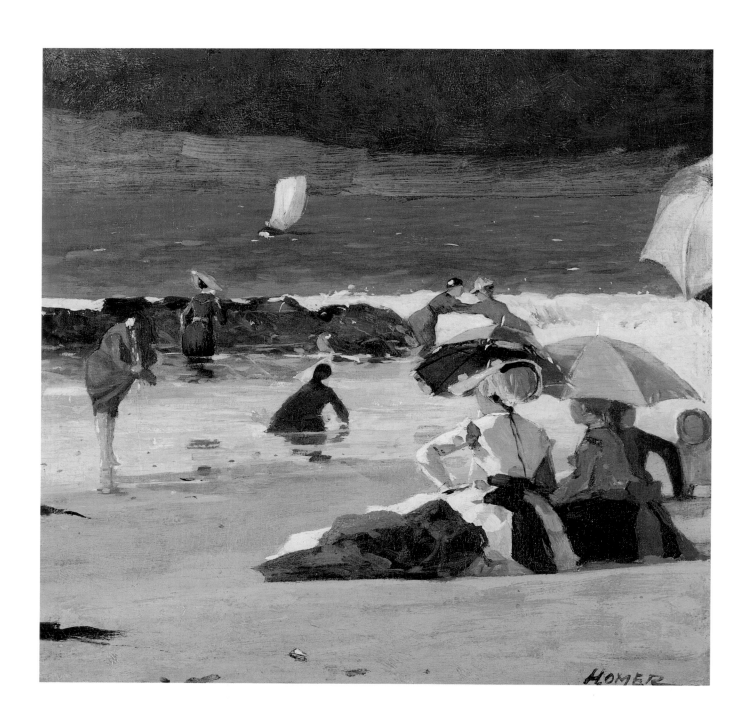

Winslow Homer

b. Boston, Massachusetts, 24 February 1836
d. Prout's Neck, Maine, 29 September 1910

BY THE SHORE, 1868–72
Oil on canvas
9 1/2 x 10 in. (24.1 x 25.4 cm)
Signed: "Homer" lower right corner

Just back from ten months in Paris, Homer based himself in New York City late in 1867. Summering in the resort towns of New Jersey, upstate New York, and Massachusetts, he found subjects for winter studio work in town. *By the Shore,* dominated by two well-dressed women seated on the sand under parasols, resonates with small beach scenes painted during the 1860s and 1870s by French maritime artist Eugène Boudin (1824–1898). Boudin's cool silvery lighting, blond tonalities, and rapid execution probably encouraged Homer to lighten his palette and loosen up his brushwork.

By the Shore was cut down from a larger, more ambitious bathing picture, one of several surviving fragments in his oeuvre. A realistic treatment of everyday subjects was deemed appropriate for Homer's woodcut illustrations reproduced in popular journals, but when he translated such forthright images to the more exalted realm of fine art, he sometimes met with excoriating criticism. In 1869, Homer exhibited *Low Tide,* another complex beach scene, at the National Academy of Design. A critic for the *New York Tribune* (4 December 1869) dismissed the picture as "a Watering-place deformity," although he allowed that parts of it were "charmingly-posed little pictures in themselves." Homer subsequently cut that canvas down into two remnants, *Beach Scene* (1869, Thyssen-Bornemisza

Museum, Madrid) and *On the Beach* (1869, Canajoharie Library and Art Gallery, Canajoharie, New York).

While *By the Shore* is all that remains of Homer's second attempt at a large-scale bathing scene, it still stands as a strong geometric composition. The now-square format maintains structural stability through repeated pyramidal groupings, such as the two seated women on the beach echoed by a pair of bathers engaged in horseplay, leaning into each other as the surf crashes around them. Often the attitudes are indecorous—one girl wrings out her sopping bathing costume of heavy gray wool trimmed with red. She also appears in a woodcut, "High Tide" (*Every Saturday,* 6 August 1870), as well as another oil, *Eagle Head, Manchester, Massachusetts* (1870, Metropolitan Museum of Art, New York). Outnumbered by young women cavorting throughout the image, a single male can be identified by virtue of his hat. He is also a stock element, deployed in several of Homer's croquet scenes. Not only themes, but also recycled figures and poses knit Homer's work together as a whole.

Other bathers in the picture include a girl sitting in the shallow waters, legs awkwardly splayed out in front of her; another paddling clumsily on her stomach; and a third tentatively approaching a rolling breaker wearing a fashionable but less than seaworthy straw hat. Beyond them a full-bellied white sail catches the bright sun, pulling the eye out to sea. Half cut off, a parasol at the right edge of the canvas encourages the illusion of spontaneity, rather like a modern vacationer's candid snapshot caught in harsh, angular late-afternoon light that will soon be gone.

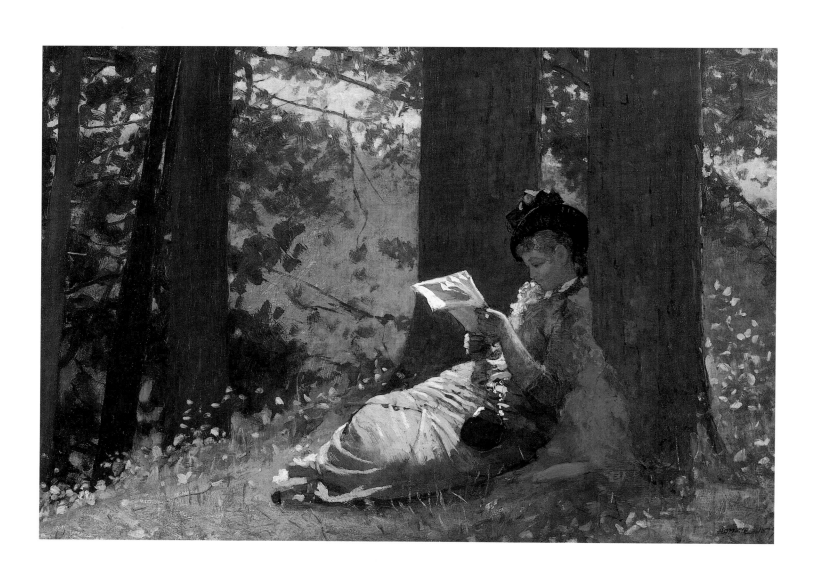

Winslow Homer

b. Boston, Massachusetts, 24 February 1836
d. Prout's Neck, Maine, 29 September 1910

GIRL READING UNDER AN OAK TREE, 1879
Oil on canvas
15 1/2 x 22 1/2 in. (39.4 x 57.2 cm)
Signed and dated: "Homer 1879" lower right corner

The country idylls comprising much of Homer's subject matter from the 1870s reveal the acute powers of observation exercised by one of America's foremost Realist painters. In *Girl Reading under an Oak Tree* Homer demonstrates an eye for the nuances of current fashion, riveting attention on his smartly dressed model. Her bright red cloak is thrown back off her shoulders for a bit of padding as she leans against a tree trunk. The girl's closely cut gray costume is enlivened with robin's-egg blue strokes capturing the folds of a tightly draped skirt. Giving the wearer a desirable "long line," such clothing stayed in vogue only briefly, from 1876 to 1882, because the restrictive pattern made the skirts so difficult to wear. Dappled light spills over lace trim cascading down the young lady's bodice and glints off the metallic chain of the reticule she holds at her side. Perched on her head, an elaborate hat is secured with a headband intended to hold it on in the breeze.

Girl Reading carries on the artist's preoccupation with images of women, often engaged in genteel activities—albeit with a cutting edge. For example, in the previous decade his croquet series, as precisely detailed as fashion plates, explored the first competitive sport in which it was socially acceptable for women to best men in public. Here, the journal or paper occupying his model invites multiple interpretations. Radiantly lit, several pages droop and fold at the corners, conjuring flimsy newsprint that could be a trope for changing gender roles and knowledge as power. Customarily men, not women, were shown reading newspapers at this time, although only the year before Homer's *Girl Reading*, Mary Cassatt dramatically challenged convention by depicting her mother with a newspaper in a white-on-white canvas titled *Reading Le Figaro* (1878, private collection, Washington, D.C.). The girl's reading material might also be seen as a nod to the influential power of the nineteenth-century art press, to which the canny Homer paid attention as he made decisions about the direction and marketing of his work. He could even be making a subtle reference to his own career as an illustrator for large-format periodicals such as *Harper's Monthly Magazine.* He gradually abandoned this lucrative but ultimately unsatisfying type of work, describing it as a form of bondage.

The painting also expresses Homer's growing commitment to issues of formalism that became overt in his work of the mid-1870s. Homer caused a stir with *Milking Time* (1875, Delaware Art Museum), a large canvas that positions figures asymmetrically against a bold horizontal grid of fence rails. In *Girl Reading,* the vertical tree trunks act similarly to pin his figure into the overall composition. Brushwork ranges from the most summarily rendered foliage to the sharp profile of the model absorbed by the printed word.

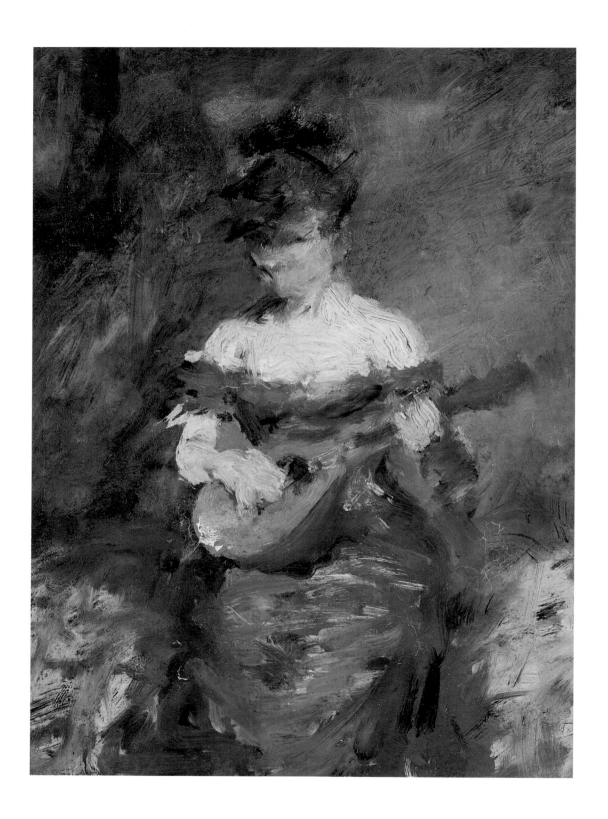

William Merritt Chase

b. Williamsburg, Indiana, 1 November 1849
d. New York, New York, 25 October 1916

A MANDOLIN PLAYER, ca. 1880
Oil on panel
10 x 7 in. (25.4 x 17.7 cm)
Unsigned

Throughout his life, Chase would make subtle reference to the arts of the past in his own pictures. A native midwesterner, Chase essentially reinvented himself as an urbane American artist and teacher after six years abroad. He entered Munich's Royal Academy in 1872, where he adopted the dark palette and energetic brushwork advocated by his German teachers. His travels also exposed him to paintings of the Old Masters. Although Chase's palette lightened in the 1880s after his contact with Belgian painter Alfred Stevens and encounters with the work of the French Impressionists (see p. 21), he never abandoned his facility with the brush. His pictures, produced in a variety of styles, regularly exhibit lively surface effects.

Freely sketched over a dark background, Chase's *A Mandolin Player* is at once old fashioned and surprisingly modern. In size and in subject the little panel, picturing a beautifully gowned woman lost in her music, recalls a precious antique cabinet picture intended for a private *studiolo.* Quick strokes of orangey red and russet create a silken shimmer, and pale pinks, thickly applied, suggest candlelight on bared shoulders. Chase's color notes conjure the music we cannot hear. His energized surface and suppression of detail signals the era's increasing demand for artistic self-expression. Spreading from the oil sketch to the full-blown exhibition picture, the trend ultimately challenged both narrative painting and academic finish.

The history of the mandolin, an eight-stringed, short-necked descendant of the lute, stretches back to the Renaissance. In the sixteenth century, musicians created the *mandola* to fill out the scale of lute ensembles. The smaller version of this traditional instrument was named by the Italian diminutive, *mandolina.* Offering evidence of nineteenth-century immigration patterns, a host of stringed instruments —zithers, mandolins, ukuleles—began to make their way into parlors where middle-class families provided their own home entertainments. The popularity of bowl-backed mandolins, such as the one depicted here by Chase, coincided with a marked increase in Italian immigration to the United States during the 1880s. Some of Chase's elaborate interiors, such as *In the Studio* (ca. 1882, Brooklyn Museum), feature a mandolin as part of the artistic bric-a-brac filling his well-known rooms in the Tenth Street Studio Building. Unlike the banjo, an instrument closely associated with contemporary women who sought economic and intellectual freedom, Chase's mandolin signified Old World sophistication. Eventually, the mandolin numbered among the first instruments recorded on Thomas Edison's phonograph cylinders.

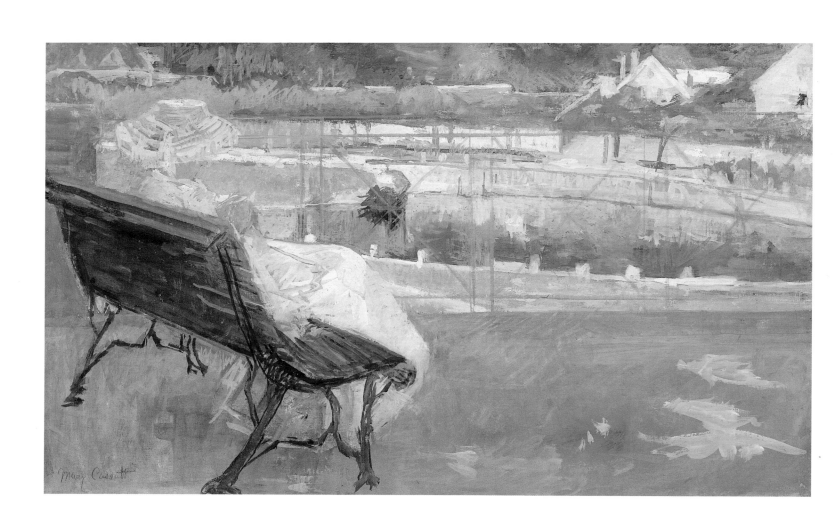

Mary Stevenson Cassatt

b. Allegheny City (now Pittsburgh), Pennsylvania,
25 May 1844
d. Mesnil-Theribus, Oise, France, 14 June 1926

LYDIA SEATED ON A TERRACE,
CROCHETING, 1881–82
Oil with tempera on canvas
15 x 24¼ in. (38.1 x 61.6 cm)
Signed: "Mary Cassatt" lower left corner

Choosing a palette as fresh as a cooling breeze, Cassatt painted this sketchy image of her elder sister Lydia plying her crocheting hook while seated on the terrace of a house in suburban Marly-le-Roi. The Cassatt family passed the summers of 1880–82 in the little town southwest of Paris, renting a property adjacent to the Château de Marly, Louis XIV's private retreat from court life. The circular pool bordered by upright white stone markers is the Abreuvoir de Marly, part of a complicated hydraulic system built in the seventeenth century to power the cascades and fountains of both Versailles and the Château de Marly. Although the château itself was destroyed during the French Revolution, the main elements of the garden and the air of quiet seclusion still survive.

Seclusion governs Cassatt's composition. A thin acid-green wrought-iron fence at the edge of the terrace separates Lydia from the view beyond—a tree-lined road linking Saint-Germain with Versailles. While Cassatt created numerous images of her sister engaged in needlework, such as *Lydia Crocheting in the Garden at Marly* (1880, Metropolitan Museum of Art, New York), here the sitter is no longer a vigorous woman. Diagnosed with Bright's disease by 1879, Lydia was already in declining health when Mary painted her on the terrace as an insubstantial, almost ghostly figure swathed in white. Sitting at the far end of the bench, half hidden by her hat, she is oblivious to her surroundings. Lydia succumbed to her kidney ailment in November 1882.

Cassatt's unusual combination of oil and tempera gives the canvas a soft, chalky surface. Rapidly slashed passages of flat color remind us that she was a close colleague of Edgar Degas, whose work she greatly admired. In May 1877 Degas invited her to join the controversial avant-garde counter-exhibitions of the French Impressionists. The only American to do so, Cassatt exhibited with them in 1879, 1880, 1881, and 1886.

After their last group exhibition, Cassatt began to revise her Impressionist style. By 1893, when she executed a commissioned mural for the Chicago World's Fair, her work had moved toward more monumental, firmly drawn images, evident in a related oil entitled *Child Picking a Fruit* (1893, VMFA). Cassatt's mural, *Modern Woman,* adorned the Women's Building. Among exhibits celebrating the achievements of female artists and designers were not only portable sinks and mechanical dusters, but also examples of fine needlework, the traditional feminine craft that so often occupied Cassatt's beloved sister Lydia.

James McNeill Whistler

b. Lowell, Massachusetts, 11 July 1834
d. London, England, 17 July 1903

GREEN AND SILVER — THE BRIGHT SEA,
DIEPPE, ca. 1883–85
Watercolor and gouache on paper
10 x 7 in. (25.4 x 17.8 cm)
Signed: with two butterflies middle right

At the time he completed this seascape Whistler was hard at work on what would become his most famous theoretical statement about art. In the "Ten o'Clock" lecture (1885), a combination manifesto and white paper, Whistler privileged formal design choices over subject matter while asserting his own aesthetic isolationism. The same detached air governs the barely ruffled surfaces of this watercolor, painted with confident washes on thick, absorbent paper.

Whistler's distanced view of the Normandy coastline, seen from high cliffs just above the beach, is as sharply angled as the Japanese woodblock prints he so admired. The artist separated the composition into just a few registers, animating the space with a dramatic diagonal line dividing an almost perfect square of sea and sand. Miniscule figures—some of them created with just two or three strokes from a fine-point brush—stroll along the strand. Fishing boats ride at anchor, their sails furled and their tall masts breaking into the horizontal band of open sky. A master of suggestion, Whister left a few spots of paper untouched to evoke cresting waves. At the horizon line, a single sailing craft implies infinite distance.

In the 1880s and 1890s Whistler frequently worked at a modest scale, reserving large canvases primarily for portraits. Whistler's full title, *Green and Silver—The Bright Sea, Dieppe,* is almost bigger than the watercolor itself, but his assured emphasis on design empowers the diminutive image, giving it a visual élan far beyond what one might expect from something so small. Whistler assigned a title combining a descriptive color harmony with a familiar geographic place name. Britons were well aware of their links to Norman history dating back to medieval times. "Dieppe" derives from the English word "deep," recognizing what had long been an important harbor on the English Channel.

Atypically, the artist signed this sheet with two butterflies, only one of which is visible here. Now covered by the picture frame, Whistler's earlier butterfly was executed in about 1883, using a slightly older, more elaborate style. When the sheet was framed for exhibition, Whistler folded back the right edge of the paper, narrowing the sheet to further emphasize the composition's sharp diagonal. This decision obscured the first butterfly—in essence Whistler's brand logo—so he added a new one, carefully positioned to balance the narrower format. Featured in 1886 at the Dowdeswell Gallery, London, in *"Notes"—"Harmonies"—"Nocturnes,"* second series, *Green and Silver* promptly sold. These delicate yet vigorous watercolor seascapes remain among the most engaging works in his oeuvre.

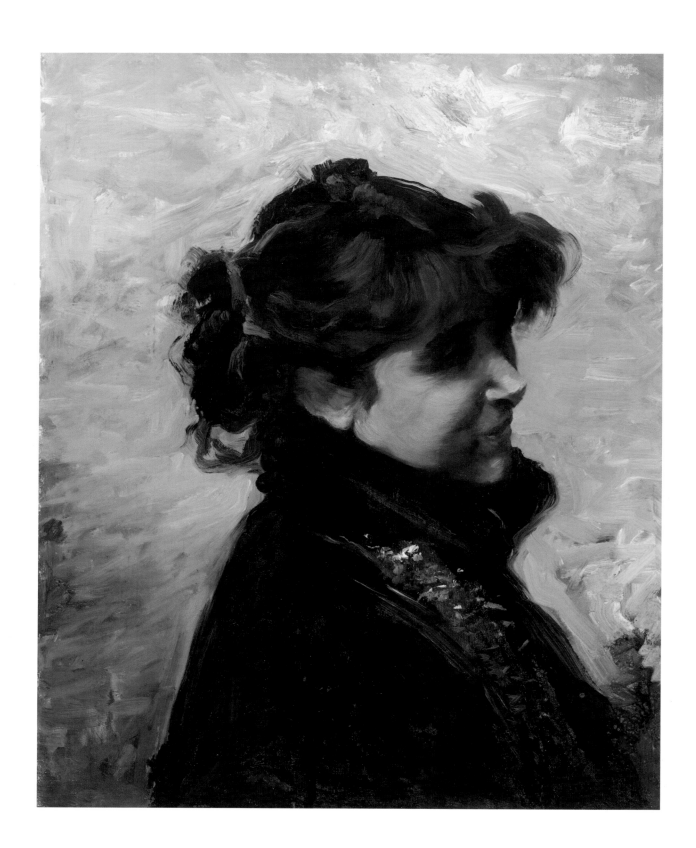

John Singer Sargent

b. Florence, Italy, 12 January 1856
d. London, England, 25 April 1925

MADAME ERRAZURIZ, ca. 1883–84
Oil on canvas
18¾ x 15½ in. (47.6 x 39.4 cm)
Unsigned

Sargent's reputation as a perceptive portraitist is justified in this vivacious image of Eugenia Huici Errazuriz (1858–1951), one of several paintings Sargent did of the Chilean-born beauty he met in Paris. As the wife of José Thomas Errazuriz, a wealthy diplomat and practicing artist, she put her brilliant social skills to good use. She and Sargent shared an international array of mutual friends, including the American sewing-machine heiress Winnareta Singer, composer Gabriel Fauré, French artists Ernest Duez and Joseph Roger-Jourdain, and Ramón Subercaseaux—another sophisticated Chilean who combined diplomatic and artistic activities. Sargent painted all of them at one time or another. His full-length canvas of Madame Ramón Subercaseaux at her piano (c. 1880–81, private collection) won a medal at the 1881 Paris salon.

More immediate than Sargent's formal salon portraits, sketches like this one honed his considerable skills at bravura painting, combining economy of means with sharp observation. Here, his rapidly moving brush revealed an attractive, expansive personality. As if caught in an outdoor snapshot, Madame Errazuriz's head turns slightly to the right, allowing a glimpse of her three-quarter profile, posed against a roughly textured wall. Framed by a standing fur collar and her own tousled hair, Eugenia's appealing countenance dominates the otherwise somber palette, relieved by only a few scumbled strokes of paint on her shoulder in the rusts and golds of scattered pheasant feathers. The portrait is one of two virtually identical versions; it descended in the sitter's family. The earlier, slightly larger canvas, inscribed "Souvenir de John S. Sargent," dates from 1880–82 (private collection, Denver).

Madame Errazuriz became one of the artist's lifelong friends, and his multiple extant images of her let us count Eugenia among the muses of his extensive career. Like Sargent himself, she eventually relocated to London, living first in Bryanston Square and later, having separated from her husband, in Chelsea, the chic bastion of London's leading artists. There, Sargent kept a studio in Tite Street, as had Whistler before him. The stylish Eugenia became an arbiter of taste, known for the elegant simplicity of her interiors in Paris, London, and Biarritz. Her modernist sensibilities embraced the new ideas of artists, writers, and musicians from Walter Sickert and Baron de Meyer to Serge Diaghilev, Igor Stravinsky, Jean Cocteau, and Cecil Beaton. She sat to Giovanni Boldini, Paul César Helleu, Augustus John, even Pablo Picasso. But among all the artists who painted this charming socialite, none captured her beauty quite so eloquently as Sargent.

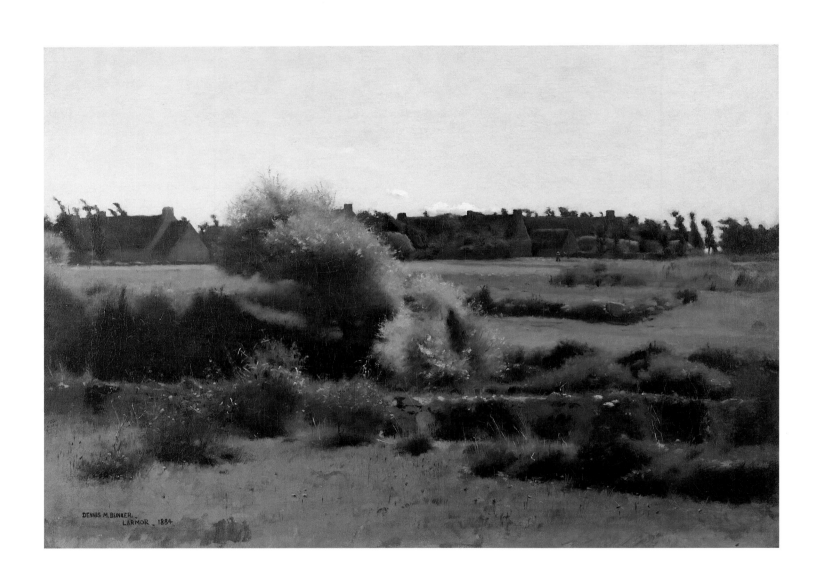

Dennis Miller Bunker

b. New York, New York, 6 November 1861
d. Boston, Massachusetts, 28 December 1890

LARMOR, 1884
Oil on canvas
18 x 25 ½ in. (45.7 x 64.8 cm)
Signed, dated, and inscribed: "Dennis M. Bunker/
Larmor 1884" lower left corner

One of the quintessential activities for American artists studying at the École des Beaux-Arts in Paris was the sketching trip into the French countryside. During the summer of 1884, Bunker and two friends traveled to the remote village of Larmor on the south coast of Brittany, a place of unchanging rural traditions. At once forceful and tranquil, Larmor's medieval stone buildings rose from a rugged, rocky landscape, far from the bustling urban streets the young painters left behind. Unlike popular artists' resorts further to the west, such as Pont-Aven, Concarneau, and Quimper, Larmor offered virtual solitude along with picturesque surroundings. "No one comes to Larmor from the outside world at all," Bunker's fellow painter Charles Adams Platt wrote home to his family.

Bunker would later recall in a letter to his friend Anne Page how French skies allowed him to "paint calmly." Over the summer, Bunker completed at least six paintings of the old Breton village, capturing a sense of timelessness bathed in a silvery opalescence very different from the harsh light of his native New England. Standing on the road leading to Pont-Aven, the artist looked back over green fields toward the heavy roofs and chimneys of the village houses. The painting is divided into horizontal bands—the empty sky, the houses, the stone fences, the hedges, the fields—punctuated by a clump of sun-struck trees breaking the horizon line. *Larmor* exhibits Bunker's developing mastery of graphic design, resulting in an image of great clarity and strength. Subtle details, such as tiny purple meadow flowers scattered in the foreground grasses, soften the image. Shaded by a large hat, a miniscule peasant standing upright in the middle distance crosses two horizontal bands to link man (the houses) and nature (the fields).

At a farewell dinner held for Bunker in Paris later that year, his teacher Jean-Léon Gérôme warned of the difficulties facing professional artists in the United States. Bunker's short career was indeed beset by financial challenges, but he would win the patronage of Boston's Isabella Stewart Gardner, as well as the unstinting admiration of both fellow artists and his own students, including William MacGregor Paxton (see p. 57). While Bunker always maintained the careful drawing learned from Gérôme, and evident in *Larmor*, he altered his style after another summer sojourn in 1888, this time with John Singer Sargent at Calcott in England. There, Bunker's palette brightened and his brushwork loosened. By the time of his death in 1890, Bunker could be credited with introducing the Impressionist style to New England.

John Singer Sargent

b. Florence, Italy, 12 January 1856
d. London, England, 25 April 1925

TWO GIRLS, 1885–86
Watercolor and graphite on paper
17 3/4 x 13 7/8 in. (45 x 35.2 cm)
Unsigned

Sargent's use of graphite both under and over passages of watercolor, coupled with his smudging of the lower figure, gives *Two Girls* a tentative, experimental air. It was painted at Broadway, an artists' and writers' colony nestled in the steep Worcestershire hills a few hours distant from London by railway. In the late summer of 1885, when Sargent made the first of his two visits to the now-famous Cotswald village, he was at low ebb. After the rigors of the *Madame X* scandal in Paris and his subsequent efforts to reestablish his career in England, Sargent despondently confided to writer Edmund Gosse that he might give up painting altogether. Fortunately, his time in the country reenergized him.

A handwritten label from the artist's memorial exhibition at London's Royal Academy in 1926 survives on the back of the picture, indicating that *Two Girls* once belonged to Mrs. Frank Millet. The charming Lily Millet presided over Russell House in Broadway with her husband, Frank, whose luminous interior costume scenes such as *A Cosy Corner* (1884, Metropolitan Museum of Art, New York) celebrated not only Dutch genre pictures of the seventeenth century, but also Broadway's rustic architecture.

Broadway charmed Sargent as it had Frank Millet. Registered at a sixteenth-century inn, Sargent spent a good deal of time with the Millets in 1885 at Farnham House (the Millets did not occupy Russell House until the following year). In the Farnham House garden Sargent began *Carnation, Lily, Lily, Rose* (1885–86, Tate Britain, London), a memorable picture of children in a garden awash in flowers and lit by Japanese paper lanterns. The next summer Sargent joined fellow painter Edwin Austin Abbey as a guest of the Millets at Russell House.

Although we cannot identify the sitters, it has been suggested that the dark setting is the Russell House barn, which Abbey had converted to a studio. At one time, the two young women in Sargent's watercolor were thought to be Kate Millet, the daughter of Sargent's host, and Polly Barnard, whose father was the English artist and illustrator Frederick Barnard. However, both Polly and Kate were still children at the time Sargent painted *Two Girls.* A more likely interpretation is that the subjects of Sargent's watercolor were participating in one of the plays regularly staged by artists summering in Broadway. Each wears a gauzy, high-waisted gown with the appearance of an old-fashioned theatrical costume. Seated on a wooden side chair, whose vigorous turned legs and stretchers Sargent reinforced heavily with graphite, one of the women holds several sheets of paper—perhaps a script. Her companion slumps close by, resting her head on the reader's lap. Sargent, too, found comfort and companionship here as the lighthearted, playful atmosphere of the place helped to improve his flagging spirits.

Seymour Joseph Guy

b. Greenwich, England, 16 January 1824
d. New York, New York, 10 December 1910

AT THE OPERA, 1887
Oil on canvas
19¼ x 15 in. (48.9 x 38.1 cm)
Signed and dated: "SJGuy 1887" lower left corner

Quickly accepted by the post–Civil War American art establishment, the British born Guy specialized in intricate genre scenes and polished portraits, particularly of children. Guy immigrated to New York in 1854 and set himself up in the Tenth Street Studio Building, then the haunt of America's leading painters (see p. 7). By 1865 he was a full member of the National Academy of Design.

At the Academy's 1874 spring exhibition, Guy's group portrait-cum-genre scene, *Going to the Opera* (1873, Biltmore Estate, Asheville, North Carolina), contrasted several generations of Vanderbilts, a family enriched by the new American railroads. Crowded into a well-appointed drawing room, William H. Vanderbilt sits by the fire with his wife. As the oldest children take leave, their younger siblings look on. A critic for the *New York Times* commented, "with two or three exceptions, they have all got their best clothes on, and are perfectly conscious that they are being looked at, yet are endeavoring to appear as if they were not."

The double-edged dynamics of self-presentation among upwardly mobile Americans of the Gilded Age intrigued artists and writers alike during the second half of the nineteenth century. Painted fourteen years after the Vanderbilt group, *At the Opera* features a fashionable young woman whose fresh complexion is enhanced by a triple strand of pearls —the natural organic gemstone long a metaphor for feminine beauty. The painting's smooth, lacquered surface respects careful glazing techniques Guy learned in England. His approach to the topic, as conservative as his treatment, aligns him with French practitioners of the *juste milieu* (happy medium), who attempted to accommodate progressive subject matter within academic style. Less threatening than other pictures made at the same time with similar compositions and content, Guy's conservative works maintained traditional roles at a time of militant feminism and other forms of social change, ensuring that his work enjoyed high regard.

Guy acknowledged that the theater, a favorite modernist subject, was the place to see and be seen. Highlights glint off the model's mother-of-pearl opera glasses, held in delicate kid-gloved fingers; but unlike Mary Cassatt's far more radical *Woman in Black at the Opera* (ca. 1879, Museum of Fine Arts, Boston), Guy's theatergoer is not shown in the bold act of using them to scrutinize other audience members. And while her pink gown trimmed with white fur parallels the bare-shouldered splendors of Cassatt's *Two Young Women in a Loge* (1882, National Gallery, Washington, D.C.), Guy records no actual setting—his background is obviously a studio drape. Cassatt, on the other hand, showed theater patrons occupying boxes above and behind her stiff, self-conscious subjects. Well positioned to stare, Cassatt's theater audience reminds us that we are doing the same thing when we gaze at her picture. In contrast, Guy's white and gold beauty is idealized, like a profile bust on a Roman coin. No audience is visible, and our own stares thus remain private.

William Merritt Chase

b. Williamsburg, Indiana, 1 November 1849
d. New York, New York, 25 October 1916

AFTERNOON BY THE SEA, ca. 1888
Pastel on linen
10 ¼ x 29 ½ in. (50.8 x 76.2 cm)
Signed: "Wm M. Chase" lower left corner

In the 1880s American Impressionists welcomed pastel, finding the medium especially suited to capturing ephemeral light effects—a lesson not lost on younger American Realists such as Everett Shinn (see pp. 41 and 47) and Robert Henri (see p. 67). Beginning in 1882, Chase worked closely with Robert Blum (see p. 31) to organize the Society of Painters in Pastel. When the Society opened its first exhibition in 1884, the *Art Exchange* averred, "'Impressionism' is here seen at its sanest and best, and those who are susceptible to the charms of cleverness and dash can find much to delight them."

This large image, with its elegant palette and sly narrative content, was exhibited in the Society's fourth exhibition (1890). Later it was confused with another pastel called *Gravesend Bay,* which referred to an historic spot in New York harbor where the British landed on Long Island to wrest control of New Amsterdam from the Dutch. Recently, scholars discovered a review in *The Studio* (17 May 1890) that establishes the correct title:

> In the *Afternoon by the Sea* Mr. Chase has attempted a subject more in the nature of genre than is usual for him. A young mother hushing to sleep a child in her arms sits in her chair on a terrace by the sea, while a girl of twelve leans on the railing, idly watching the boats as they come

and go. The party is completed by two dogs, nicely characterized and cleverly painted; a poodle shaved lion-fashion, and a pug, with its close, short . . . hair neatly modeling its fat body.

Chase's slightly angled composition recalls a seaside painting by the influential Belgian artist Alfred Stevens, *In Deep Thought* (1881, St. Louis Art Museum). But Chase transformed his source into an understated little scenario of idleness and activity.

Sturdy linen rather than fragile paper was better suited to support a pastel of this size. Pale, densely applied chalks evoke the hazy moist air of a coastal summer's day. Passages of ochre and green in the largely empty foreground suggest small branches scattered by a recent thundershower. Contrasting play and work, Chase created a frieze of sail-powered yachts along with industrial craft whose stacks emit pale grey or puffy white clouds of steam.

Facing outward, the alert poodle is hard at work keeping the terrace free from intruders such as ourselves. Meanwhile, the pug replicates the contemplative activity of the young girl standing at the fence. Chase further links them by giving the pug a bright blue bow, echoing the girl's light blue coat and tam. While passing boats may be the chief focus of her interest, Chase reinforced the girl's motionlessness with a detail, almost obscured by an iron fence and a large tree trunk. Out in the water, two miniscule dots of red lead the eye to a pair of women bathers, wearing caps as they cavort around a wooden float.

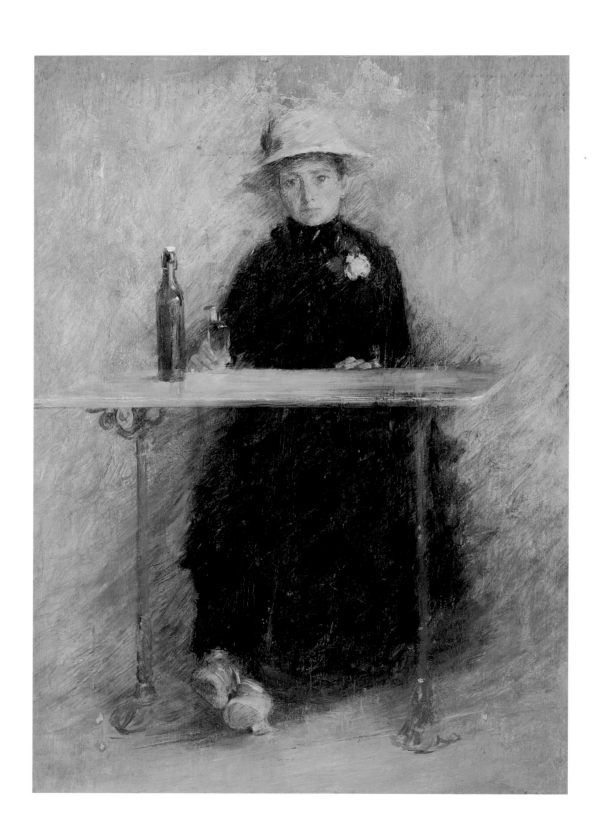

Theodore Robinson

b. Irasburg, Vermont, 3 July 1852
d. New York, New York, 2 April 1896

PORTRAIT OF MADAME BAUDY, 1888
Oil on panel
13 x 9½ in. (33 x 24.1 cm)
Inscribed, signed, and dated: "To Madame Baudy/
Th. Robinson 1888" upper right corner

Dressed in somber black, relieved only by a straw hat, pale shoes, and a tiny rose corsage, Angélina Baudy (1852–1949) sits before a warm ochre background suggesting afternoon sun on a plastered wall. She rests her left-hand fingers lightly on the marble surface of a sidewalk table. Her stemmed glass, along with the single green bottle beside her, suggests that she has paused for *un petit blanc*—a little glass of white wine—and a rest. She was the proprietress of the Hôtel Baudy in Giverny, a small French village between Paris and Rouen where Claude Monet had his famous studio and flower garden. As American artists eager to meet Monet flocked to Giverny, the Hôtel Baudy became the temporary residence of choice.

Acting as agent for a Parisian firm, the enterprising Madame Baudy sold paints and canvases to visiting artists. Robinson was among the first American painters she met. He may have visited Giverny as early as 1885, and he made annual stays of several months in the late 1880s and early 1890s, often registering at the Hôtel Baudy. Artist and sitter were approximately the same age. However, Angélina would long outlive the gentle, frail Robinson, plagued by asthma throughout his too-brief career—a situation perhaps reflected in the solemn air that pervades this image.

The portrait combines hard and soft edges, while precise details and textural contrasts coexist with generalized, freely brushed passages. Well trained in the academic tradition, Robinson had attended the National Academy of Design before studying in Paris with Charles Carolus-Duran from 1876 to 1878 (Sargent was among his fellow pupils). Robinson also studied with the French painter Jean-Léon Gérôme. An entrenched habit of skillful drawing is evident here, for example, in Robinson's careful limning of the Queen Anne heels on Madame Baudy's beribboned shoes. Yet, while Robinson played off surfaces, such as polished marble against light-absorbent black fabric, his brushwork testifies to the growing friendship he enjoyed with Monet by the late 1880s. Returning to the United States in 1892, Robinson published an article on Monet in the September issue of *The Century Magazine.* Although Robinson himself never adopted broken color to the extent Monet did, he admired the Frenchman's paintings. As he wrote in his journal, he aimed in his own work to mingle Impressionist "brilliancy and light of real outdoors" with "the austerity, the sobriety, that has always characterized good painting."

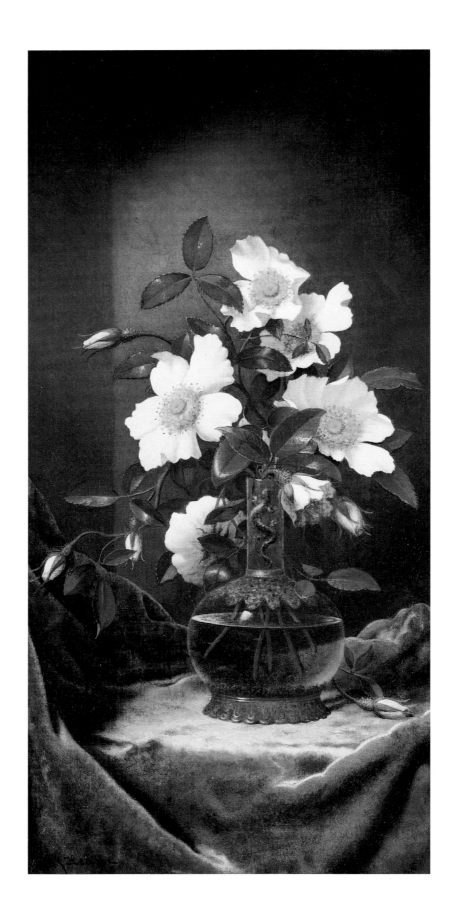

Martin Johnson Heade

b. Lumberville, Pennsylvania, 11 August 1819
d. St. Augustine, Florida, 4 September 1904

WHITE CHEROKEE ROSES
IN A SALAMANDER VASE, 1883–95
Oil on canvas
26 x 13 in. (66 x 33 cm)
Signed: "M. J. Heade" lower left corner

Over the course of a long, highly independent career, the peripatetic Heade scrutinized a variety of sensuous and exotic forms. He found unexpected subjects in places as disparate as the flat New England coast and the tangled jungles of Latin America. Starting in 1859, Heade defied the conventions of landscape composition, abandoning panoramic vistas for subdued glimpses of salt marshes in Massachusetts, Connecticut, and New Jersey. In pictures such as *A Cloudy Day* (1874, VMFA), he painted low, horizontal bands of watery land and cloudy sky, punctuated by rounded stacks of marsh grass. The highly poetic series captures fleeting, sometimes eerie light effects. Inspired by his travels to Brazil, Nicaragua, Columbia, Panama, and Jamaica between 1863 and 1870, Heade commingled landscape and still life in an intensely focused series of hummingbirds, orchids, and passion flowers.

In 1883, Heade located permanently in St. Augustine, Florida, where he soon enjoyed the patronage of Henry Morrison Flagler. The land developer provided the artist with a permanent studio behind the new Ponce de Leon Hotel. Still-life painting, a genre that had engaged Heade since 1860, became the mainstay of his work. Of the 150 known pictures he created after moving to Florida, two-thirds are still lifes. Most are horizontal, like his earlier marsh scenes. But not *White Cherokee Roses in a Salamander Vase.* The roses stand upright in a glass and gilt-bronze container resting on a table set in a corner and awkwardly bedecked with bunched and draped blue-green velvet. The composition provides the usual opportunities for a skillful still-life painter to render contrasting textures—silken velvet, transparent glass, shiny metal, waxy leaves, soft flower petals. Some of the roses are still in bud, others have fully opened, allying Heade's image to traditional European *vanitas* still lifes expressing the transience of beauty and the passage of time.

In studies such as *Branches of Cherokee Roses* (ca. 1883–88, St. Augustine Historical Society), Heade observed the flowers with the precision of a botanist in his laboratory. However, the painting of Cherokee Roses in a vase offers added touches of ancient history and local color. Used in herbal medicine since the third century A.D., *Rosa laevigata* was brought to America by the East India Company in 1759. It soon grew rampant in the southern United States, where, as the Cherokee Rose, it eventually became the official state flower of Georgia. These white and yellow blossoms figure in traditional Native American legends. Cherokee Indian braves gathered the roses to make bridal garlands said to ensure marital happiness. Heade's Victorian brass-mounted vase reinforces the message. It is ornamented with a salamander, a creature long associated with both bravery and chastity.

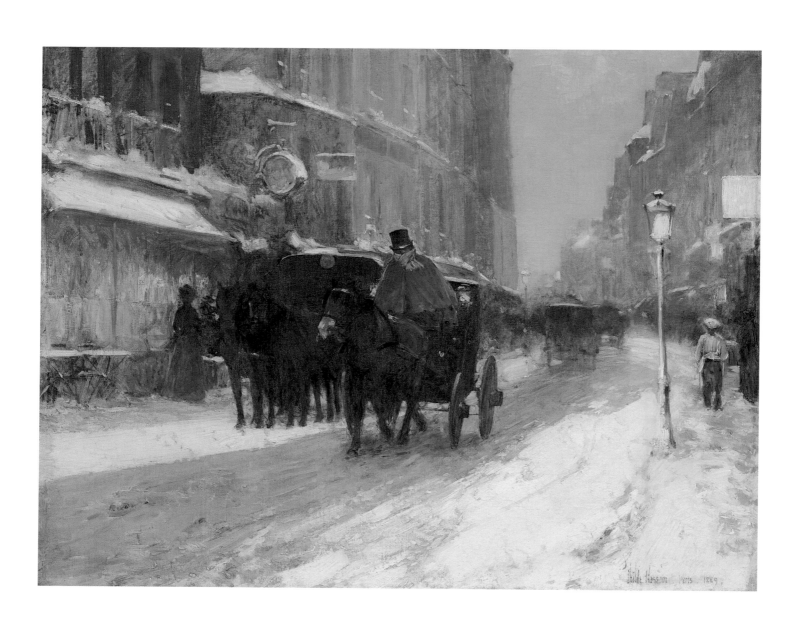

Childe Hassam

b. Dorchester, Massachusetts, 17 October 1859
d. East Hampton, New York, 27 August 1935

WINTER NIGHTFALL IN THE CITY, 1889
Oil on canvas
25 1/2 x 33 in. (64.8 x 83.8 cm)
Signed, inscribed, and dated: "Childe Hassam Paris
1889" lower right corner

Already established in Boston as an accomplished
painter of atmospheric street scenes, Hassam left for
Paris late in 1886 to spend three years abroad. There
he studied drawing at the Académie Julian, founded
in 1868 to prepare students to pass entrance exami-
nations at the École des Beaux-Arts. Hassam was
too advanced an artist to need the state-run academy,
but by the last decades of the nineteenth century,
a little French finish had become almost requisite
for successful American artists. More importantly,
Hassam garnered formative exposure to the work
of modern French painters, including not only
Impressionists and Neo-Impressionists, but also
artists of the *juste milieu* (happy medium) who
captured subjects from modern life using more
traditional styles. Hassam would eventually arrive
at a conservative version of Impressionism himself—
his lingering solidity of form typifies the American
approach to the movement.

Although the anglophile Hassam later refuted all
attempts to link him with French Impressionism,
which he believed to derive from eighteenth-century
English art, his Parisian sojourn loosened his brush-
work and lightened his palette. Casting himself in
the role of *flâneur*, Baudelaire's anonymous observer
who, as a "passionate spectator" set himself up "in
the heart of the multitude," Hassam continued his
earlier exploration of urban street scenes, finding
himself particularly drawn to the genteel and pictur-
esque aspects of life in the French capital.

Here, Hassam captures an animated glimpse of a
commercial street at the end of a chilly winter day
as dusk gives way to night. Snow, piled up along
the slushy pavement, also blankets pitched dormers,
hanging shop signs, sagging awnings, and project-
ing windowsills. Hassam's otherwise somber palette
of whites, grays, browns, and low-toned greens
is brightened by touches of yellow and orange—
inviting spots of light radiating from carriage lanterns
and shop fronts. A large glowing swath emanates
from the half-curtained windows of a bistro, its
sidewalk tables abandoned in the snow. A woman
walks towards the entrance, marked out by a potted
evergreen tree. Her receding movement is paralleled
on the opposite side of the street by an aproned
shopkeeper's assistant engaged in delivering what
appears to be fresh baked goods. As a foil to the
pedestrians, a carriage travels smartly toward us,
driven by a *cocher* or cabdriver in top hat and cape.
Hassam emphasized the sense of speed by blurring
the carriage horse's legs, in contrast to those of
a team hitched to a delivery wagon that stands
stock-still. The fiacre—a small four-wheeled hack-
ney coach drawn by a single horse—was among
Hassam's favorite urban motifs. An almost identical
cabbie appears in *Along the Seine, Winter* (1887,
Dallas Museum of Art), reminding us that Hassam
was fond of painting picturesque city traffic under
atmospheric weather conditions. When he returned
to the United States he would continue to follow
this formula in paintings like *Late Afternoon, New York:
Winter* (1900, Brooklyn Museum of Art). American
Realists such as Everett Shinn subsequently made
similar choices (see p. 41).

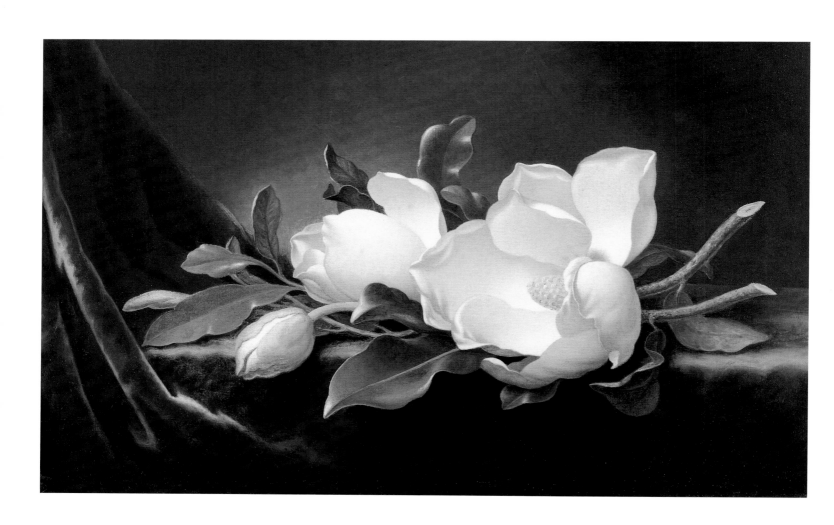

Martin Johnson Heade

b. Lumberville, Pennsylvania, 11 August 1819
d. St. Augustine, Florida, 4 September 1904

TWO MAGNOLIAS AND
A BUD ON TEAL VELVET, ca. 1885–95
Oil on canvas
15 x 24 in. (38.1 x 61 cm)
Signed: "M. J. Heade" lower right corner

The handsomely shaped *Magnolia grandiflora* flourishes across America's Southeast, from Virginia to Mississippi to Florida. Attracted by the stately tree's shining dark leaves and colossal flowers, Heade made at least five oil sketches of this well-known variety of the magnolia family, including *Study of Three Blossoms of Magnolia* (ca. 1883–88, St. Augustine Historical Society). Like the *Cherokee Roses* (see p. 25), Heade's close-up images of magnolias are difficult to date precisely. Seventeen finished works are known, depicting from one to three voluptuous blossoms each. Consistent with Heade's other work, the majority of the magnolia paintings are horizontal in format. Those showing three blossoms on blue-green velvet are thought to be the culmination of his series.

Magnolias are among the oldest types of deciduous trees on the planet. Heade's presentation of the virtually life-size blossoms lying on their soft, light-absorbent drapes achieves an almost unsettling timelessness. Recalling the three ages of man, *Two Magnolias and a Bud on Teal Velvet* presents a bud just starting to open; a second flower with its petals beginning to spread, capturing the light in the hollows of its cupped curves; and a radiant, gloriously full-blown blossom that reveals its fruiting cone.

It is little wonder that contemporary writers sometimes find Heade's series to be highly suggestive. In the "language of flowers," compilations of floral symbolism that were especially popular during the Victorian era, magnolias signified beauty, feminine charm, ostentation, even self-esteem. The artist, whose earlier wanderings included a brief stint as a portrait painter in Richmond (1845–46), has created what are essentially unconventional "portraits" of the magnificent flowers, charged with a latent sexuality. His palette is reduced to the creamy yellowish whites of the fleshy petals, the gleaming waxen green leaves with their cinnamon-brown backs, the lights and shadows of the velvet drape, the low-toned unarticulated background. A later scholar went so far as to liken one of Heade's magnolias to a seductive odalisque, stretched out on her luxurious divan. The flowers still carry connotations of welcome in southern culture today.

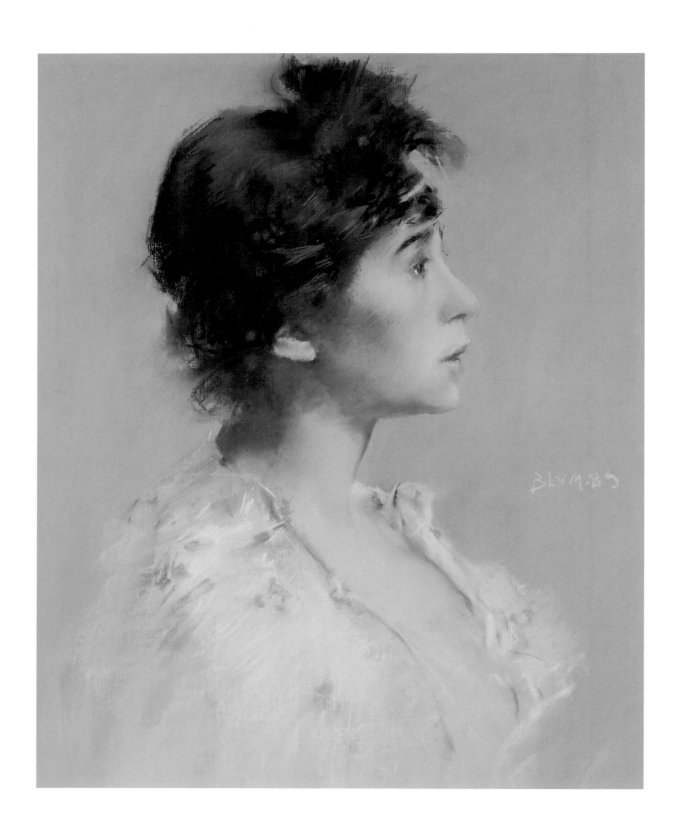

Robert Frederick Blum

b. Cincinnati, Ohio, 9 July 1857
d. New York, New York, 8 June 1903

FLORA DE STEPHANO, THE ARTIST'S
MODEL, 1889
Pastel on paper
20 1/2 x 18 1/4 in. (52.1 x 46.4 cm)
Signed and dated: "Blum·89" middle right edge

In 1882 Blum joined William Merritt Chase (see p. 21) to found the Society of Painters in Pastel, serving the New York group as president. A critic for the *Art Amateur,* reviewing the society's 1884 exhibition, noted that pastel was no longer just "the parent of certain wooly and faded portraits haunting the deserted upper rooms of country houses." Certainly, Blum's shimmering likeness is filled with light. The artist had become romantically involved with Flora de Stephano during his travels to Venice in the late 1880s. His evanescent colors—delectable notes of coral, cream, lemon, mauve, and peach against a velvety surface of canary yellow—capture the pert profile of his Italian model and muse. The work reflects the aesthetic impact of James McNeill Whistler, whose controversial exhibition of Venetian pastels at the Fine Art Society in London brought fresh attention to the medium in 1881. The impressionable young Blum saw some of Whistler's pieces when he met the American expatriate in Venice the previous summer.

If the use of pastel evidences Blum's modernism, it also nods to the importance of this fragile medium to French Rococo artists a century earlier. Blum maintained an interest in the Rococo throughout his career, later embarking on light-hearted mural decorations for Mendelssohn Hall in New York (1893–ca. 1898, now Brooklyn Museum).

Blum also loved things Japanese. Unlike Whistler, who was thoroughly engaged with Japanese art but never actually traveled to Asia, Blum did eventually visit there to illustrate a series of articles on Japan for *Scribner's.* After completing his commission, Blum stayed on in Japan to create a number of major easel paintings. One of them, *Temple of Fudo Sama at Meguro, Tokyo* (1891), is now in the collection of the Virginia Museum of Fine Arts. The canvas, still in its original frame, once belonged to Flora de Stephano.

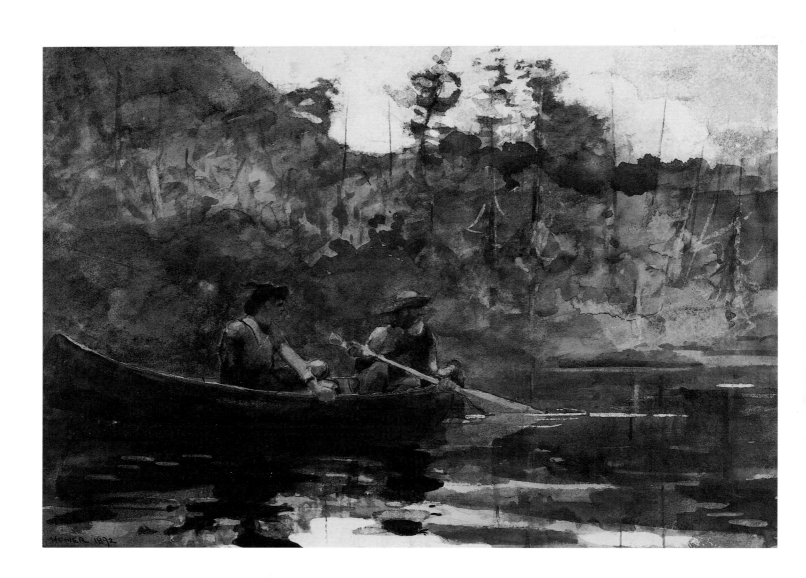

Winslow Homer

b. Boston, Massachusetts, 24 February 1836
d. Prout's Neck, Maine, 29 September 1910

CANOEING IN THE ADIRONDACKS, 1892
Watercolor over graphite on paper
15½ x 20 in. (39.4 x 50.8 cm)
Signed and dated: "Homer 1892" lower left

Homer's comment, "You will see, in the future I will live by my watercolors," is borne out by this richly worked image of woodsmen afloat on a sylvan lake. *Canoeing in the Adirondacks* belongs to an important group of pictures Homer produced from 1891 to 1894, at the height of his power as a watercolorist. They have always received just admiration. In December 1892, a critic for the Boston *Evening Transcript* enthused, "we have looked over a portfolio of his watercolor sketches of the Adirondacks . . . and we are more than ever impressed by the superb breadth and mastery." Homer's Boston dealer, Doll and Richards, sold a number of them at $175 or more each—then a considerable sum.

Brushed with remarkable aplomb, these accomplished works blend realism with abstraction, apparent spontaneity with clever artifice. Homer employed multiple techniques. In wet-on-wet passages, deep colors pool with mesmerizing intensity. Other colors recede like waning forest light where he subtracted pigment with a damp sponge. Calligraphic strokes call forth a gnarled pine, a wavering reflection. A broken white line, scratched through pigment into the paper itself, conjures the silvery wake trailing a paddle half raised from the still waters.

The activities Homer pictured were vanishing under pressure from commercial loggers and eager tourists.

By the 1840s, recreational hunting and fishing offered service jobs outside the region's well-established lumber industry. When Homer made his first visit to the Adirondacks in the 1870s, the area already had more than two hundred hotels. When he returned in 1889, conservation-minded urban professionals and businessmen were acquiring large acreages and converting them to private clubs such as the North Woods Club, where Homer regularly lodged.

Homer had undertaken painting campaigns in the area in 1889 and 1891, concentrating on scenes of summer fishing and autumn hunting. But in 1892, he made two month-long visits, focusing on local guides whose considerable skills enabled city dwellers, somewhat derisively called "sports," to enjoy the great outdoors safely. In this watercolor, the older man is based on Rufus Wallace, who worked at the North Woods Club for years. The younger man resembles Michael Francis Flynn, only briefly employed at the club between 1891 and 1892. In half a dozen works from 1892, Homer paired the two woodsmen, idealizing them in a classic juxtaposition of youth and age, strength and wisdom. Here, the bearded paddler pauses to look over his shoulder, as if listening to some sound in the forest. His clean-shaven, muscular passenger also looks back, but there the narrative ends. What Homer offers in lieu of a tale is his admiration for the skills of these woodsmen and his longing for a simpler time. Sport fishing has been a contemplative activity since Isaak Walton penned *The Compleat Angler* in 1653. Homer's magnificent watercolors merit similar contemplation.

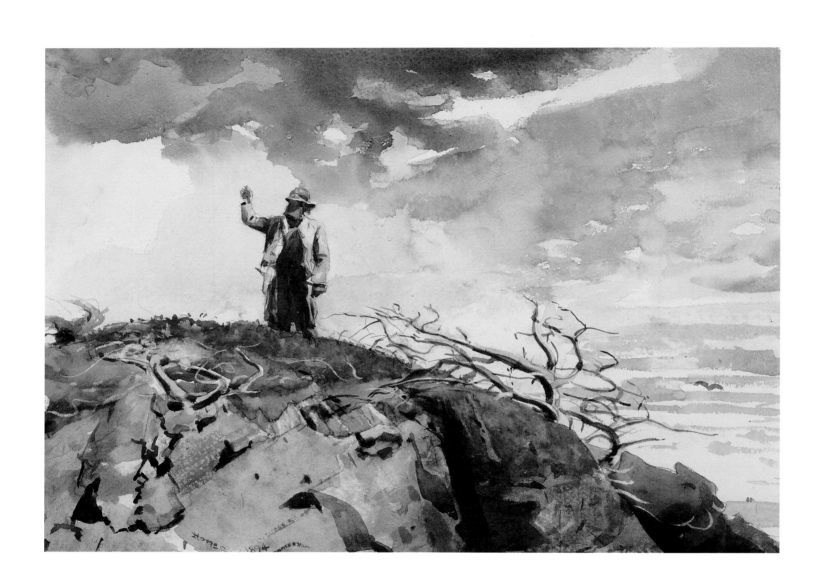

Winslow Homer

b. Boston, Massachusetts, 24 February 1836
d. Prout's Neck, Maine, 29 September 1910

THE WATCH, EASTERN SHORE,
PROUT'S NECK, 1894
Watercolor over graphite on paper
15 1/2 x 20 in. (39.4 x 50.8 cm)
Signed and dated: "Homer 1894" bottom left edge
Inscribed, verso: "Here you Are—Big Thing W.H. 1894"

As Homer's fluently brushed watercolor suggests, forbidding grey cliffs and stunted trees twisted by prevailing winds endow Prout's Neck with weather-beaten beauty. Ten miles south of Portland, the peninsula juts out into the Atlantic Ocean, completely exposed to easterly storms that rake the Maine coast. After 1884 Homer lived on the grounds of his family's compound at Prout's Neck. His spartan studio-home, heated only by a stove, situated the artist just above massive rocks battered by spectacular surf.

This watercolor of a local fisherman silhouetted against a stormy sky had hardly dried when the artist included it in a solo exhibition with his Boston dealers, Doll and Richards (December 1894). Then titled *Man on the Mountain,* the powerfully rendered image is part of Homer's continuing engagement with the elemental struggle between man and nature, the key theme of his work after his sojourn in the English fishing village of Cullercoats at the edge of the treacherous North Sea (1880–81).

Homer's model, wearing a slicker and sou'wester hat, has been identified as John Getchell. The figure's isolation recalls the artist's own desire for solitude, giving him direct contact with the wild aspects of nature that inspired some of his most moving

works. On the back of the sheet, Homer wrote an inscription to his friend Louis Prang, a lithographer and publisher who purchased the watercolor in 1895, making a few lithographs of the image in reverse the following year. Homer had defended his solitary habits to Prang in an earlier letter:

> I deny that I am a recluse as is generally understood by that term. . . . I do my own work. No other man or woman within half a mile & four miles from railroad & P.O. This is the only life in which I am permitted to mind my own business. I suppose I am today the only man in New England who can do it. I am perfectly happy & contented.

Homer's business was to create memorable pictures, as carefully calculated as they were seemingly spontaneous. The dramatic composition seen here was a favorite of his; many variations on the theme of one or more figures isolated against the sky and seen from below can be found in his work.

In *The Watch,* Homer gives only a tiny glimpse of the ocean in the lower right-hand corner. While the waters are calm, the sky is threatening. Beginning with *Dad's Coming* (1873, National Gallery of Art, Washington, D.C.), the theme of separation and anxious waiting for loved ones to return from the perilous, ever-changeable seas resonates through four decades of Homer's work.

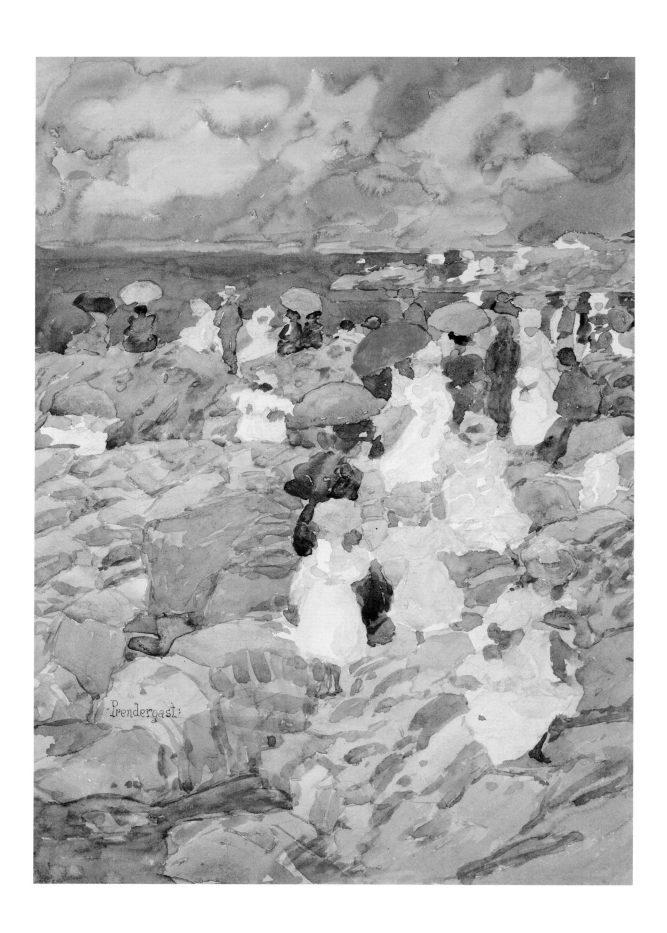

Maurice Brazil Prendergast

b. St. John's, Newfoundland, 10 October 1858
d. New York, New York, 1 February 1924

HANDKERCHIEF POINT, ca. 1896–97
Watercolor over graphite on paper
13 1/2 x 9 5/8 in. (34.3 x 24.5 cm)
Signed: "Prendergast" lower left

By 1889 Prendergast was spending his summers painting the newly emergent middle class at play along the Massachusetts coast. *Handkerchief Point* belongs to a group of watercolors of the late 1890s in which the Canadian-born former commercial artist began to develop a distinctive personal style after three years of studying in Paris (1891–94). Watercolors like this one set Prendergast in the forefront of Americans who fully absorbed and synthesized the impulses of French modernism. Remaining open to new modes of painting throughout his career, Prendergast would eventually join with Everett Shinn (see pp. 41 and 47), Robert Henri (see pp. 61, 67, and 69), and other members of The Eight in their 1908 exhibition challenging the conservative National Academy of Design. In 1913, he helped to organize the controversial Armory Show, which brought advanced painting styles before the general American public.

Here, Prendergast engaged a theme that would fascinate him throughout his career—urban crowds enjoying earned leisure in seaside and park settings. The site is probably Nantasket Beach, a popular resort close to Boston and accessible by both steamboat and railway train. The place name, "Handkerchief Point," is thought to refer to a spot on the rocks of Nantasket where spectators stood to wave at passing steamers.

The vertical composition with its sharply tilted viewpoint and high horizon line reflects the Japanese prints Prendergast encountered during his studies, as well as his interest in surface patterning and compositional arrangements pioneered by James McNeill Whistler (see p. 11). Prendergast's exuberant deployment of color incorporates the decorative practices of the Nabis, an avante-garde group of colorists led by Pierre Bonnard, Edouard Vuillard, and Maurice Denis. For example, parasols rendered in geometric half-circles spiral upward; the most vivid red ones counterbalance horizontal passages of brilliant blue, as bracing as the gusts of sea air ruffling voluminous summer dresses.

Prendergast structured these fashionable dresses with silvery graphite lines, leaving some of the bright white paper support in reserve. He used soft tints—ochre, pink, pale green, moss green, brown, and lavender—to detail sashes, pinafores, puff sleeves, and other sartorial embellishments. Color also shapes the sun-washed rocks. Despite its abstraction, Prendergast's image conveys the sense of children clambering past their adult companions, who bend gracefully toward one another in conversational groups. A few males appear in the crowd, distinguished by their hats. They are far outnumbered by women and children—most middle-class men were at work.

Modern in both its theme—urban leisure—and its treatment—vibrant surface patterning—*Handkerchief Point* is dominated by a patriotic color scheme of red, white, and blue. Prendergast's decorative shapes and sparkling puddles of color capture a festive holiday mood. As one journalist commented in 1899, "Mr. Prendergast . . . carries a whole Fourth of July in his color-box."

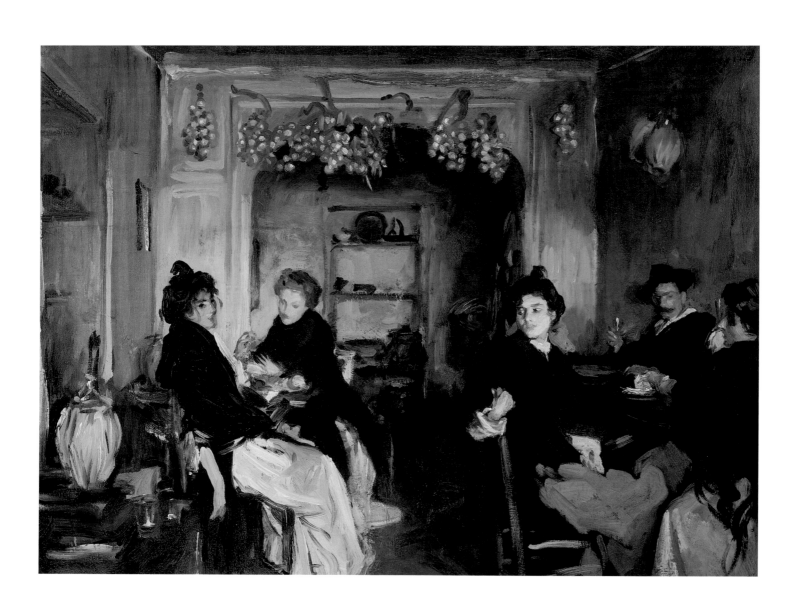

John Singer Sargent

b. Florence, Italy, 12 January 1856
d. London, England, 25 April 1925

VENETIAN WINESHOP, ca. 1898
Oil on canvas
21 x 27 1/2 in. (53.3 x 69.8 cm)
Signed: "John S. Sargent" upper right corner

With dramatic lighting and bold brushwork, Sargent provides what first appears to be a random glimpse into a traditional Venetian *bacaro,* or wineshop, stocked with raffia-covered bottles, festooned with strings of garlic, and jammed with little tables and straight-backed chairs. The image is actually a carefully constructed aesthetic tableau. A single female model seems to have posed for three figures: the one wearing a vivid red skirt and leaning back in her chair to dominate the space, as well as the two dark-haired beauties whose mirror-opposite profiles bracket her in the forward picture plane. Seated in the far corner and raising a wine glass, a man wearing a slouch hat recalls a similar model that Sargent painted twenty years earlier in *The Sulphur Match* (1882, Hugh and Marie Halff collection). Fascinated by humble bead stringers, water carriers, and other laborers in Venice since his visit in 1882, Sargent is here rendering types, not portraits, although the lighter-haired woman sitting at a back table with a plate of snacks set before her has been identified as the artist Jane de Glehn. Along with her husband, Wilfred, Jane often accompanied Sargent, who regularly painted his traveling companions. The de Glehns are likely the figures pictured in *The Sketchers* (1913, VMFA), an oil showing a couple of artists working outdoors.

Sargent's modest neighborhood wineshop was probably located in one of the narrow little streets near the seventeenth-century Palazzo Barbaro. Daniel Curtis, a wealthy Bostonian, acquired the historic property in 1885, and Sargent often stayed with the Curtises, to whom he was distantly related. His resplendent image of the Curtises at home in their grand saloon, *An Interior in Venice* (1898, Royal Academy, London), marks his gradual move away from formal portraiture, of which he grew increasingly weary. Eventually, it was to Mrs. Curtis that he confided in 1907, "I have vowed a vow not to do any more portraits at all . . . it is to me positive bliss to think I shall soon be a free man."

Painterly freedom is the hallmark of *A Venetian Wineshop.* Almost monochromatic, the image commands attention with its single, splashy passage of bright red. The animated interplay of figures spreads across the canvas, while thick highlights pull the eye from near into far space and back. Light glitters off the nearest wine bottle and again off the man's raised wine glass in the far corner. The plate on Mrs. de Glehn's table counterbalances another on the table next to the woman in red. White dresses and voluminous black shawls are sketched in with brilliant rapidity. Sargent is as relaxed in his brushwork as his figures are posed in their chairs. Not in the least sacrificing realistic effect, Sargent needed only three fluid strokes with a quarter-inch brush— successively loaded with ochre, pink, and coral— to create the illusion of the forearm and hand of the woman lolling next to the large demijohn of wine in the foreground.

Everett Shinn

b. Woodstown, New Jersey, 6 November 1876
d. New York, New York, 1 May 1953

HORSEDRAWN BUS, 1899
Pastel on paper
21 3/4 x 29 5/8 in. (55.3 x 75.3 cm)
Signed and dated: "Everett Shinn /99" lower right corner

In 1893, a very young Shinn abandoned the practical field of industrial design to seek a more interesting career in painting, entering the Pennsylvania Academy of the Fine Arts in Philadelphia. Reluctant to lose his father's support, Shinn helped defray expenses by working as an illustrator for the *Philadelphia Press* in an era when commercial photography was unknown. Reliant upon quick preliminary sketches made at the site of some newsworthy event, illustrators hurried back to their studios under the pressure of relentless printing deadlines. Aided by their sketches, the most accomplished of them exercised a sharp memory for salient detail, speedily executing their compelling final images.

Shinn's path quickly crossed like-minded artists, particularly George Luks, who was also combining newspaper work with further study. Luks urged Shinn to attend lively Tuesday evening discussions led by Robert Henri, then an instructor at the Pennsylvania Academy. Fellow news illustrators William Glackens and John Sloan were soon part of their circle. Henri's encouragement helped all four men bridge the gap between illustration and fine art—each would be counted among the most important American Realist painters within a few years.

Shinn moved to New York in 1897. The spectacle of the urban streets, literally a continuing performance,

fascinated him. Here, Shinn created a stage-like space to focus on an early mode of public transportation that helped make the sprawling modern city and its suburbs navigable. First seen in London and Paris during the early nineteenth century, horse-drawn buses were already being supplemented with more rapid forms of urban travel including the streetcar and the underground. By 1899, Shinn's choice of topic, emphasizing melodrama as well as reportage, was as picturesque as it was contemporary.

Shinn deftly mixed his artistry with his reporting skills. His palette, confined to icy blues, stark white, and unrelieved black, is as frigid as his subject matter. High above, a bleak glimmer of yellow light in two upper-story windows gives the only promise of shelter from the cold. Two weary horses and their driver lean into the storm. The omnibus door stands ajar—a woman has just alighted. Bent almost double, she battles her way toward us as her wind-whipped umbrella threatens to turn inside out. Funneled by the unyielding row of buildings, a fierce gale slices down the almost empty street. Using multiple diagonal scribbles of white chalk over a gritty dark ground, Shinn encouraged the viewer to feel the chill blast.

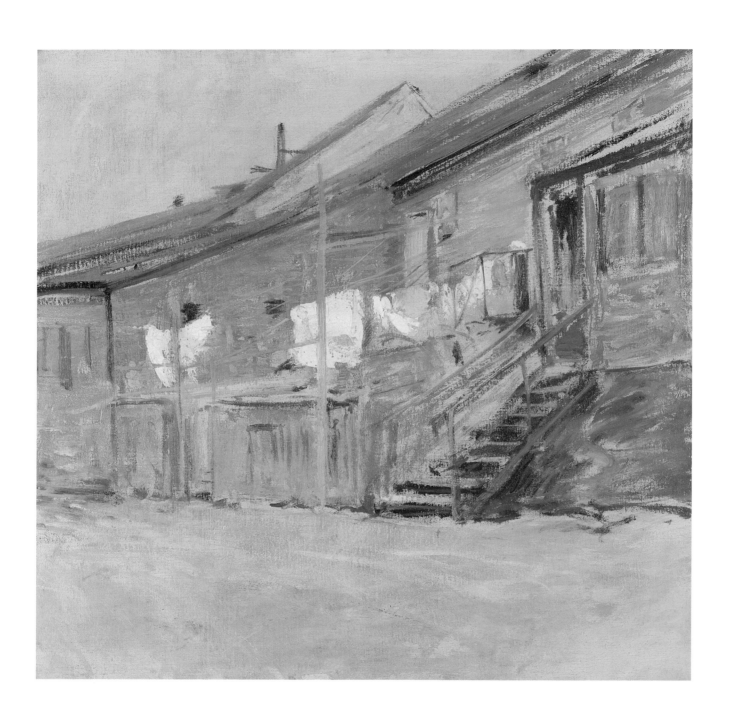

John Henry Twachtman

b. Cincinnati, Ohio, 4 August 1853
d. Gloucester, Massachusetts, 8 August 1902

GLOUCESTER, FISHERMEN'S HOUSES,
ca. 1900
Oil on canvas
25 x 25 ½ in. (63.5 x 64.8 cm)
Unsigned

With its vigorous brushwork and economy of detail, *Gloucester, Fishermen's Houses* captures "the spirit of the scene not the letter" (Katharine Metcalf Roof, *Brush and Pencil,* 1902). While both French and American Impressionists favored images of middle-class leisure, Twachtman's choice of a blue-collar subject—a rickety row of wooden dwellings in a coastal Massachusetts fishing village—indicates that tougher, labor-related topics were also addressed.

Unlike the Realists, however, the Impressionists tended to provide psychological distance when exploring such issues. The deserted street takes up the bottom third of the canvas, leaving space between the viewer and the sunbleached houses. More than just a reminder that fishermen were out working, melancholy empty space combines with thin dry brushwork to suggest dilapidation. Twachtman poetically intimated hard facts: small independent fisheries were a disappearing way of life all along the eastern seaboard. However, Impressionists were also noted for their optimism. Freshly washed laundry—including a workman's blue shirt—hangs on lines next to weathered wooden stairs. As one scholar recently noted, in American art, the laundry is always clean.

Gloucester was already a popular, picturesque artists' haunt by the time Twachtman conducted three summers of art classes there, from 1900 to 1903. His own emphasis on design in *Fishermen's Houses*—geometric blocking and a striking red/green complementary color scheme—controls the picture's challenging square format, associated with avant-garde painting. Like a number of the artists discussed in this catalogue, Twachtman had extensive formal training and went through various stylistic changes during his career. The Cincinnati-born artist studied with Frank Duveneck, accompanying him to Germany in 1875. There he spent three years at Munich's Royal Academy, absorbing the same techniques of free brushwork and dark palette that William Merritt Chase learned just before him (see p. 7). After a stint in New York at the Art Students League, Twachtman went to Paris in 1883, enrolling at the Académie Julian to improve his draftsmanship. Works such as *Arques-la-Bataille* (1885, Metropolitan Museum of Art, New York) evidence his encounter with the decorative patterning of expatriate James McNeill Whistler. Twachtman's palette lightened and he adopted a modified Impressionist technique much influenced by his friend Theodore Robinson, whom he first met in Paris (see p. 23).

In 1897, Twachtman joined Childe Hassam and J. Alden Weir to found the Ten American Painters, a group of Impressionists who abandoned the Society of American Artists to exhibit on their own. Of all of them, Twachtman's work became the most subtle, complex, and abstract. While his paintings were never particularly marketable in his own lifetime, Twachtman enjoyed widespread admiration from his fellow artists. Shortly before his untimely death, the tonalist painter Thomas Wilmer Dewing told readers of the *North American Review* (April 1903) that Twachtman was "the most modern spirit, too modern, probably, to be fully recognized or appreciated in his own day."

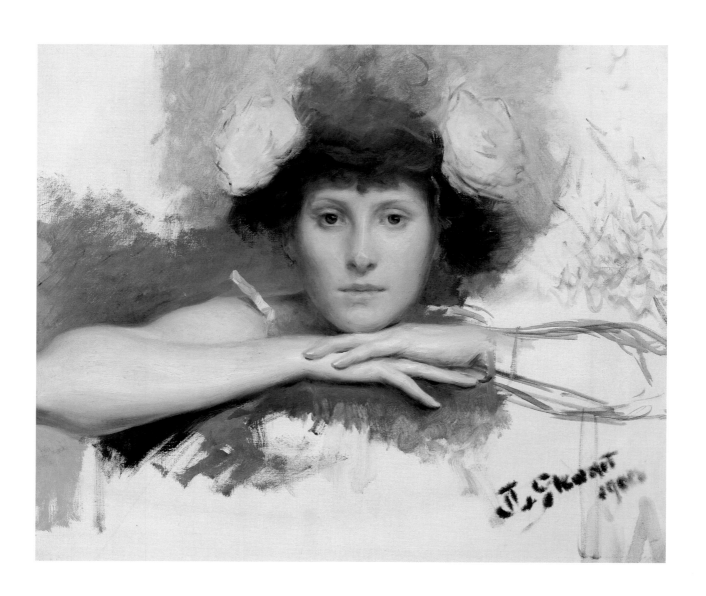

Julius LeBlanc Stewart

b. Philadelphia, Pennsylvania, 6 September 1855
d. Paris, France, 5 January 1919

FLOWERS IN HER HAIR, 1900
Oil on canvas
19 x 23¾ in. (48.3 x 60.3 cm)
Signed and dated: "JL Stewart 1900" lower right corner

Were it not for Stewart's prominent signature and date, one might mistake *Flowers in Her Hair* for a preparatory study. Sketchy but compelling, its appeal lies in the young girl's frank gaze, further intensified by unfinished passages and sections of empty canvas that surround her. This is an unusual picture by the expatriate American artist best remembered for his soigné portraits of celebrities and society figures such as the wife of an American banker, *Mrs. Francis Stanton Blake* (1908, Walters Art Museum, Baltimore). Stewart also created elaborate narrative genre scenes and nudes painted in the open air.

Stewart's career transpired in Europe after he moved with his family from Philadelphia to Paris in 1865. Through his father, William, a wealthy patron of contemporary Spanish and French painters, he had access to leading figures in the Parisian art world—including Eduardo Zamacois, a genre painter, and Federico de Madrazo, portraitist to the Spanish court—whose work his father collected. After studying with these artists of the Spanish school, Stewart developed strong drafting skills under the French painter and teacher Jean-Léon Gérôme and traveled with him to Egypt in 1875. Stewart synthesized a colorful academic realist style, attracting collectors after his initial showing at the Paris Salon of 1878. Like Sargent, he drew both subject matter and patronage from a circle of well-heeled expatriate

Americans and their European friends. Elected to the French Legion of Honor in 1895, Stewart was appointed an officer six years later.

Stewart was also active in arranging for American participation in various international art exhibitions. Among them, the Paris *Exposition Universelle* in 1900 witnessed a determined effort, supported by the imperialistic McKinley administration, to establish American art on a par with that of the Europeans, particularly the French. Stewart's *Nymphes de Nysa* (undated, Musée d'Orsay, Paris), a precisely finished work typical of his large, sun-dappled female nudes, was acquired by the French government after the fair.

At the *Exposition Universelle* nations battled for international artistic prestige, but the fair also established Art Nouveau as a significant ornamental style dominated by feminine imagery and natural plant forms. Painted in the year of the Paris fair, *Flowers in Her Hair* subtly addresses the Art Nouveau femme fatale. Stewart's carefully balanced composition is almost architectural in its symmetry. Crowned by a pair of full-blown but indeterminate flowers, the model rests her chin on folded hands. Silent as a sphinx, she blocks our entry into her private world, one in which the status of women was in flux. *Flowers in Her Hair* claims affinity not only with Stewart's glamorous portraits and genre scenes, but also with arresting turn-of-the-century popular imagery as commercialized as Alphonse Mucha's lithographs of women with flower crowns and whiplash tresses, advertising everything from champagne to cigarettes. And, if Stewart's model simply smolders, the architect Stanford White's mistress leaves no doubt in Rudolf Eickemeyer, Jr.'s similarly posed photograph *Evelyn Nesbit/Beauty as Evidence* (1901, Drapkin Collection).

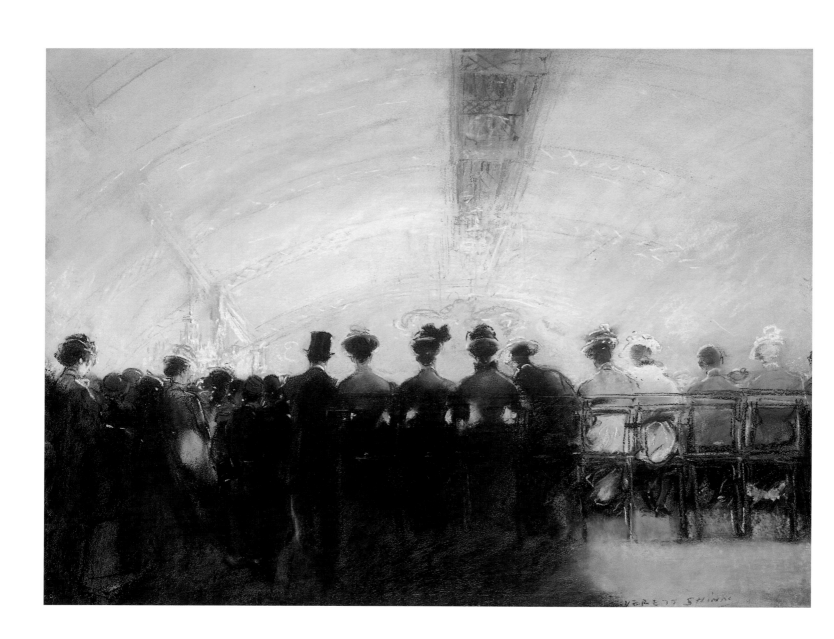

Everett Shinn

b. Woodstown, New Jersey, 6 November 1876
d. New York, New York, 1 May 1953

BACK ROW, FOLIES-BERGÈRE, 1900
Pastel on paper
20 1/2 x 27 in. (52.1 x 68.6 cm)
Signed: "Everett Shinn" lower right corner

A burst of sulfurous yellow light emanates from a stage hidden below rows of spectators who occupy the cheapest balcony seats at the Folies-Bergère in Paris. Cocked heads and bent shoulders, rendered in smudgy blacks, browns, grays, and whites, suggest mesmerized Parisians caught unawares under limelight reflected off a gracefully arched roof. Elbows akimbo, three spellbound ladies form a highly contrasting black and yellow pattern that centers the composition. The uneven silhouette of their prim decorated chapeaux, along with top hats and straw boaters, echoes a faint, wavering line suggesting ornamentation on the proscenium arch. While we cannot see the show itself, Shinn's own performance with his colored chalks on paper is memorable, marking his growing fascination with the theater.

Under the direction of the entrepreneurial Leo Sari, the Folies-Bergère, conveniently located in the Rue Bergère close to the *grands boulevards,* became a popular venue for commercialized entertainment during the Second Empire. Emulating London's music halls, it featured elaborate evening spectacles: trained animals, acrobats, comedians, even entire operettas and ballets. Sari supplemented his own house orchestra and dance troupe with current vaudeville and circus celebrities. He charged two francs for the least costly seats, five for reserved seats; drinks were expensive. In *Bar at the Folies-Bergère* (1881–82, Courtauld Institute Galleries, London), Edouard Manet painted one of the two principle spaces—the horseshoe-shaped theater with fixed orchestra seats, crystal chandeliers, marble bars, and commodious promenades. Shinn seems to have chosen the upper reaches of "The Garden," a vast balconied hall covered by a stretched canvas awning supported on iron struts and girders.

Shinn had been an avid amateur actor and set designer since his early days in Philadelphia. Once in New York, acclaim for his American street scenes, purchased by patrons as distinguished as William Merritt Chase, prompted his New York dealer to send him to Europe to record street life in London and Paris. While abroad, Shinn was further captivated by the glittering theater world, a significant modernist topic seen in pictures by everyone from Auguste Renoir, Edgar Degas, and Mary Cassatt to Jean-Louis Forain. Inspired by these artists, Shinn created a large group of bold pastels featured by Boussod, Valadon and Company upon his return to New York. The solo exhibition, titled *Paris Types,* included 46 pastels, *Back Row* among them. Having met Elsie de Wolfe, an American actress, Shinn enlisted her help in promoting the new work. De Wolfe showed the pastels to her friend and mentor, the influential, high-living architect Stanford White. Both de Wolfe and White encouraged their prominent circle to attend, and sales were brisk. The first owner of *Back Row* was the wife of tycoon J. Pierpont Morgan.

Theater would remain one of Shinn's most important interests. His career even included a stint in motion pictures as art director for Metro Goldwyn Mayer in Los Angeles.

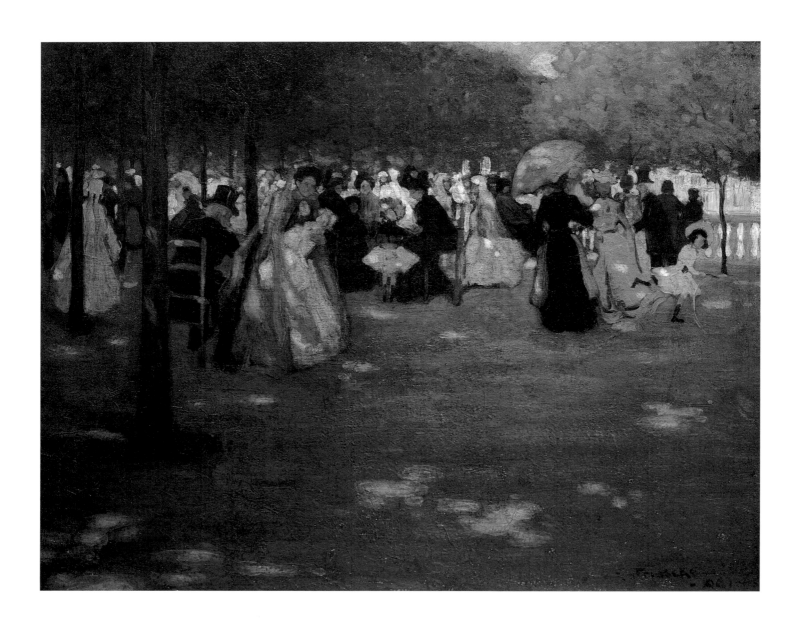

Frederick C. Frieseke

b. Owosso, Michigan, 1874
d. Mesnil-sur-Blangy, France, 1939

LUXEMBOURG GARDENS, 1901
Oil on canvas
26 x 32 in. (66 x 81.3 cm)
Signed and dated: "F. Frieseke 1901" lower right corner

Luxembourg Gardens, created for Marie de' Medici in the seventeenth century, remains one of the most popular public spaces in Paris. Frieseke shows us some of the types the garden attracted in his day: ladies wearing afternoon dresses and bonnets with trailing ribbons, gentlemen in top hats, a mother whose baby is swathed in white lace, a child in high-buttoned boots chasing her hoop, even a servant with starched white apron and parasol. The distinctive stone balusters glimpsed in Frieseke's picture were recorded earlier by Sargent's *In the Luxembourg Gardens* (1879, Philadelphia Museum of Art).

After 1897, Frieseke spent virtually his entire career in France. As one of Monet's neighbors at Giverny, Frieseke eventually specialized in sunlit garden and interior scenes. *Blue Interior: Giverny* (1912–13, VMFA) exemplifies his highly keyed colors and elegant surface patterning. First admired and acquired by Europeans, Frieseke's work was eagerly sought in the United States following his 1912 solo exhibition in New York and his grand-prize-winning display at the 1915 Panama Pacific International Exhibition at San Francisco (see p. 65), which helped to confirm American Impressionism as a preeminent style in American collecting circles. In 1932, a journalist for *The Art Digest* called Frieseke "America's best known contemporary painter," adding "even the smallest of the public galleries is pretty sure to have a Frieseke."

Yet by then, prevailing winds of abstraction were sweeping domesticated aestheticism aside. Virtually forgotten by the 1950s, Frieseke's work was rediscovered by scholars and collectors at the end of the twentieth century.

Frieseke's mature style was fed by his engagement with European modernism of the 1860s and 1870s. In *Luxembourg Gardens* Frieseke revisited well-known compositions by Edouard Manet and James McNeill Whistler. Manet's *Music in the Tuileries* (1862, National Gallery of Art, London) presents a fashionable Second Empire crowd attending an afternoon outdoor concert. Manet brought his figures right up to the picture plane, immersing the viewer in the throng. Frieseke, on the other hand, kept his distance, simplifying the composition considerably. He left the entire foreground—roughly half the canvas—empty except for passages of dappled light breaking through the canopy of plane trees.

Frieseke's debt to Whistler is evident in the frieze-like arrangement of figures set in the middle ground and harmonized into a sinuous line of whites, grays, and blacks punctuated with carefully orchestrated color notes in pink and red. Save for a tiny patch of blue sky, the figures are held in a horizontal register under densely leaved trees. The scene recalls Whistler's view of a London outdoor resort, *Cremorne Gardens, No. 2* (1872–77, Metropolitan Museum of Art, New York).

The Luxembourg Palace, set in the gardens, became a public gallery in 1802 as a result of the French revolution. Among the prizes later on view was Whistler's *Arrangement in Grey and Black, Portrait of the Painter's Mother,* acquired in 1891 amid international fanfare. A canvas by Frieseke joined his countryman's in this prestigious collection by 1904.

John Singer Sargent

b. Florence, Italy, 12 January 1856
d. London, England, 25 April 1925

PORTRAIT OF AMBROGIO RAFFELE,
1904–11
Watercolor over graphite on paper
20 x 14 in. (50.8 x 35.6 cm)
Inscribed and signed: "all' amico A Raffele John S
Sargent" lower right corner

Starting in 1904, Sargent avoided the heat of summer by making regular trips to the Italian Alps. As was frequently his custom, he traveled with artistic friends, among them the Italian landscape painter Ambrogio Raffele (1845–1928). Helen Barlow, who met both men at the Bellevue Hotel on the Simplon Pass in 1910, later recalled that Raffele "was a dear old fellow" who "couldn't talk any English except the word 'yes' which he always insisted the English pronounced 'Hyes' . . . so if you met him on the stairs . . . he always said 'Hyes' with a twinkling eye."

Sargent painted several other portraits of Raffele including a cleverly composed oil known as *An Artist in His Studio* (1904). Purchased for Boston's Museum of Fine Arts in 1905, it was the first subject picture by Sargent to enter an American museum. Sargent sometimes referred to the Boston canvas as "No Nonsense," for it humorously addresses one of his favorite themes: a fellow artist hard at work. In that image Raffele is shown literally trapped in his hotel room-cum-studio at Purtud in Val d'Aosta. Crammed into a corner, he sits awkwardly on an uncomfortable rush-seated ladder-back chair set before an unfinished picture. He is surrounded by chaos, from the tangled bed linens to his scattered clothing to assorted oil sketches lying about.

A critic for the *Boston Herald* later noted that the picture "gives, without any romantic feelings whatever, the realities of the artistic struggle."

In contrast, this watercolor image of Raffele is deceptively simple. With one hand resting on the latch, the painter seems to have shut the door on his artistic struggles, at least for the moment. Distinguished by a full beard and splendid curling mustachio, the slightly disheveled Raffele looks out engagingly from the light-flooded corner where he stands at ease. His rumpled trousers and mismatched jacket are beautifully rendered in wet washes of blue, violet, and gray pigment. Unlike his formal commissioned oil portraits, Sargent's watercolors retain a breezy, spontaneous energy. Although the artist himself didn't take these works very seriously, they reveal at once the release he enjoyed when working—seemingly without effort—in this challenging medium and the delight he took in the friends and family he captured on paper. Many of his finest watercolors were given as gifts, often, as in this case, inscribed with a brief dedication.

George Wesley Bellows

b. 12 August 1882, Columbus, Ohio
d. 8 January 1925, New York, New York

MAY DAY IN CENTRAL PARK, ca. 1905
Oil on canvas
18 x 22 in. (45.7 x 55.9 cm)
Signed: "Bellows" lower left corner

Bellows was an American Realist who became famous for his dark, hard-hitting series of prizefighting images. However, this early work uses vivid splashes of red and orange to pull viewers into the heart of a far gentler scene—the annual May Day festivities held in Central Park's Sheep Meadow. Wearing white clothing, long associated with purity and innocence, young girls in a small group carry the May Pole, decked with colorful blossoms and trailing bright ribbons. Centered under the floral canopy, the tallest girl, crowned with an elaborate headdress and carrying a large bouquet of flowers, has doubtless been chosen as the May Queen. Following the central group, a throng of children, all in white, stretches far back into the meadow, framed by dark, overarching trees.

May Day itself, a spring ceremony emblematic of rebirth and renewal, dates to pagan times. But this modern celebration is set on public parkland developed by Frederick Law Olmstead in the mid-nineteenth century as part of his democratic vision of making open spaces available to the urban poor. Progressive New Yorkers intended public parks to promote the health and well-being of the entire population, and local health-care needs were a prime focus of the May Day activities in Central Park. Organizers from the city and its schools combined parades, pageants, and athletic events with health checks and examinations, as well as instructive poster and essay contests.

Bellows depicted the social diversity that made New York City the nation's cultural capital by the early twentieth century. Ahead of the children in white, several boys slouch along, hands in pockets. The artist linked them to the parading girls with color—two wear white shirts, the third a red and white letter sweater. These young touts, two of them puffing cigarettes, are probably not part of the procession itself, although in traditional English May Day parades, chimney sweeps as well as Morris dancers preceded "milkmaids" clad in white. Rather, they are among the various types of people attracted by the spectacle, contrasting sharply with a genteel mother who watches the procession while flanked by her well-dressed children. Two black-clad figures observe the parade from the lower right corner of the picture, their gaze replicating our own. The artist's bold application of thick pigments is as energetic as the scene itself. By emphasizing urban dwellers over urban settings, Bellows and his fellow Realist painters moved away from the distanced images of the Impressionists, engaging viewers in the very pulse of the modern city.

53

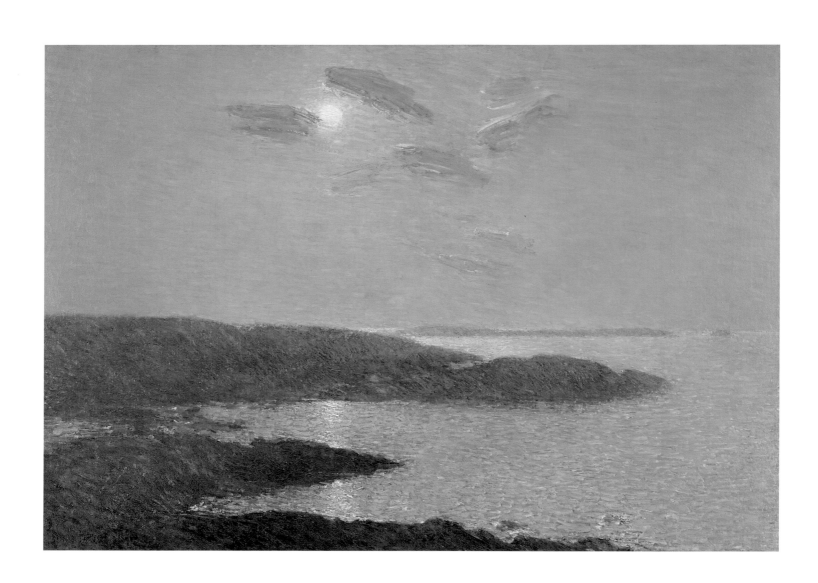

Childe Hassam

b. Dorchester, Massachusetts, 17 October 1859
d. East Hampton, New York, 27 August 1935

MOONLIGHT, 1907
Oil on canvas
25¾ x 36¼ in. (65.4 x 92.1 cm)
Signed: "Hassam 1907" lower left corner, inscribed
verso "C.H."

A leading practitioner of Impressionism in America, Hassam conducted multiple painting campaigns on the Isles of Shoals, a remote group of small islands off the Maine/New Hampshire coast. While his images of the Shoals comprise only about ten percent of his large oeuvre, they number among his finest works, created from the time of his initial documented visit (1886) until the First World War.

During a time of significant social, political, and economic change, many Americans longed for a romanticized "simpler" past. In pictures such as *In the Garden* and *The Garden in Its Glory* (both 1892, both Smithsonian American Art Museum, Washington, D.C.), Hassam recorded a wild garden created on Appledore Island by poet and art patron Celia Leighton Thaxter. Using brilliant oils and watercolors Hassam captured the public's imagination with his extravagant masses of old-fashioned poppies, hollyhocks, and rambling roses — "the flowers our grandmothers loved" — bathed in bright sunshine.

Drawn to the island rocks as well as its flowers, the artist continued to seek lush color effects even after the sun went down. Calling Hassam a "leader of the open air school," a critic for the *Evening Post* (12 December 1907) praised *Moonlight* when it was exhibited in New York shortly after its completion in 1907:

> Conspicuous on the broad wall is a moonlight shore scene from the Isles of Shoals, in which small clouds swarm about the moon like fish round a golden bait. Depth of perspective and a happy suggestion of color in the shoals make this nocturne one of the most successful pieces in the collection.

Sunsets and moonlight tempted Hassam with opportunities for highly keyed nocturnes and symphonies inspired by Whistler. Early on, critics picked up Whistlerian overtones in Hassam's work, even calling him a "butterfly artist." He learned a great deal from the elder statesman of aestheticism, whom he admired greatly. Whistler's aesthetic manifesto, the "Ten o'Clock" lecture, was part of Hassam's summer reading at the Shoals.

In large-scale pictures such as *Moonlight,* Hassam manifested a sensitivity to color that Whistler himself might have envied. The large, simple forms of the composition are rendered in intricate color stitchery. Tiny strokes of brown and purple conjure the weathered headlands; turquoise, blue-gray, and blue-violet the relentless tide. Hassam gentled the ancient confrontation between rocks and water with rich blue strokes cast over both, linking them together in a moonlit mist sparked by beams of light dancing on the waves.

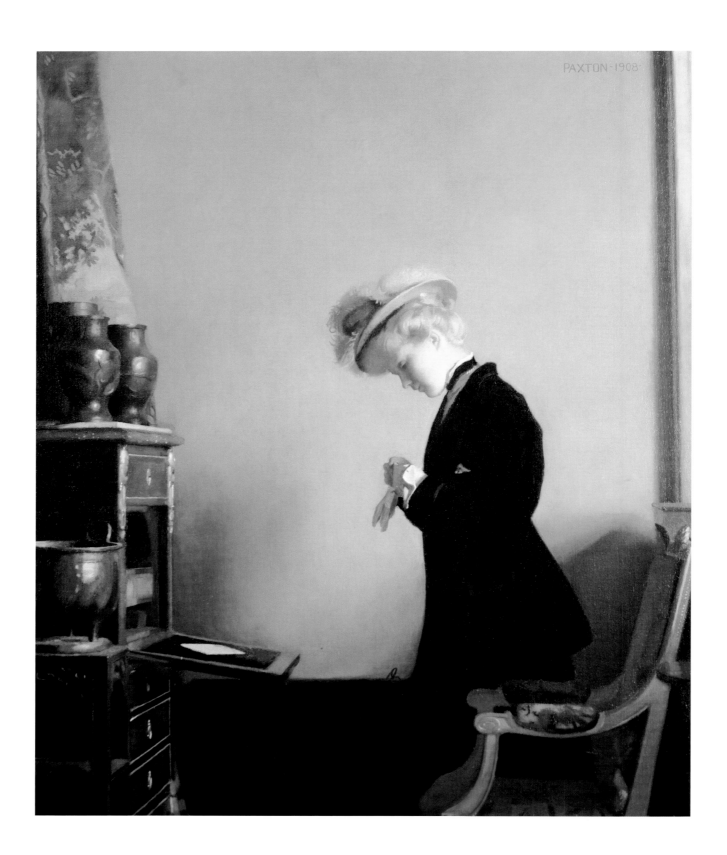

William McGregor Paxton

b. Baltimore, Maryland, 22 June 1869
d. Newton, Massachusetts, 13 May 1941

THE LETTER, 1908
Oil on canvas
30 x 25 in. (76.2 x 63.5 cm)
Signed and dated "Paxton-1908"

In *The Letter,* an elegant young woman is silhouetted against an empty wall, buttoning—or unbuttoning—one of her gloves. A silvery gray feathered hat crowns her pale hair, setting off a faint blush in her cheek. Head bent, she is lost in contemplation. Opposite the immobile figure, inanimate objects bathed in the ambient light parallel her beauty. A piece of European tapestry hangs in the corner. Matching Asian bronze vases perch on the marble-topped desk, while a footed urn occupies a carved plant stand next to it. Metallic highlights gleam from gilded and polished surfaces. Amidst Paxton's nearly colorless tonalities, a white envelope with a red postage stamp stands out on the blue-green baize drop-front of the luxurious desk. The curving arm of a gilt-wood chair sets up a circular movement that focuses the eye upon the letter and the lady.

We cannot say whether Paxton's model has just come in or is on her way out. She may have just received the letter, or perhaps she intends to mail it. Paxton completed *The Letter* only three years after Edith Wharton's controversial *House of Mirth* connected themes of youthful beauty and compromising correspondence in a novel of manners skewering New York society. Intended for a more straight-laced Boston audience, this smoothly brushed painting offers an urbane, open-ended narrative leaving much to the viewer's imagination. Therein lies its appeal.

Along with his colleagues Edmund Tarbell, Frank Benson, and Joseph De Camp, Paxton led the conservative "Boston School" of painters, observing high technical standards to produce genteel, cosmopolitan images. *The Letter* resonates with the chic materialism expressed in late-nineteenth-century European portraiture by Alfred Stevens, James Tissot, and Paul Helleu. The picture's stark background wall and darkly clad figure in silhouette recall *Lady with a Glove* (1869, Musée d'Orsay, Paris), a fashionable Second Empire portrait by Charles Carolus-Duran.

However, Paxton would also have been the first to acknowledge his debt to the seventeenth-century Dutch master Jan Vermeer. Having completed early studies in Boston with Dennis Bunker (see p. 15), Paxton was in his third year of training with Jean-Léon Gérôme at the École des Beaux-Arts when several Vermeer pictures were sold at auction in 1892. They once belonged to Théophile Thoré, an influential French critic who championed the Dutch master as a precursor to Impressionism. Among the buyers was Isabella Stewart Gardner, one of Boston's most prominent collectors. Recognizing the taste for Dutch pictures in Boston, Paxton incorporated many of Vermeer's motifs into his own work. Here, the roseate light, the device of the letter, the richly textured incidental objects, and even the placement of a chair in the foreground derive from Vermeer. Paxton later assisted a fellow Boston artist, Philip Hale, in editing the first American book on Vermeer, published in 1913.

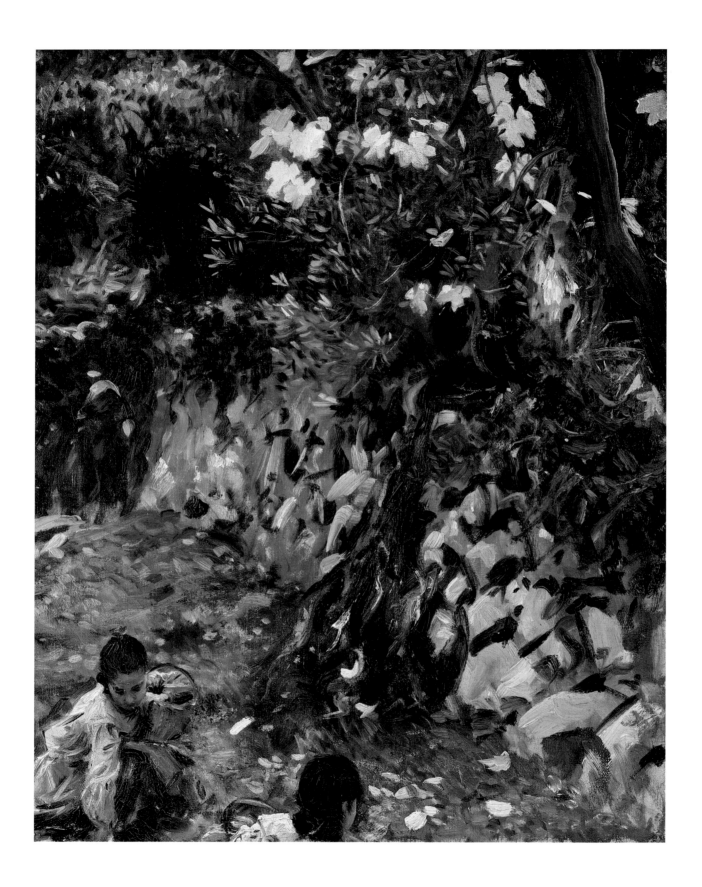

John Singer Sargent

b. Florence, Italy, 12 January 1856
d. London, England, 25 April 1925

GATHERING BLOSSOMS, VALDEMOSA,
1908
Oil on canvas
28 x 22 in. (71.1 x 55.9 cm)
Unsigned

Composed from a high, angled vantage point, *Gathering Blossoms, Valdemosa* belongs to a group of closely related oils and watercolors that Sargent painted in Majorca, an island off the Spanish coast directly south of Barcelona. Sargent's vigorous application of paint in large, semi-independent strokes of greens, browns, tans, oranges, and yellows testifies to his stated determination to give up the stylistic strictures of lucrative charcoal "mugs" and oil "paughtraits," as he called his society commissions. Experimenting with new topics encouraged bolder treatments than he had allowed himself in the past.

On the eve of his departure for Majorca in June 1908, Sargent was full of anticipation, writing to his distant relative Mrs. Curtis, "If it is as delightful as they say, I daresay Emily [his sister] & I, and perhaps Miss Wedgwood [Emily's traveling companion Eliza] may go there in autumn." They did. Well suited to stimulate the painter's imagination, the Mediterranean island had attracted artists and writers for years. During a second visit in the fall of 1908, Sargent and his party stayed in Valdemosa. Next door was a Carthusian monastery made famous in the pages of George Sand's *Un Hiver à Majorque,* written after she spent time there with Frédéric Chopin in 1838–39.

As sensuous as Chopin's music, Sargent's treatment is so highly decorative that a shower of yellowed leaves cascading down the canvas has long been mistaken for exotic flowers. The picture has carried its misleading title since shortly after the artist's death. *Ficus carica Moracea,* the edible fig with its distinctive lobed leaves, is more easily recognized in his close-up *Study of a Fig Tree* (1908, private collection).

Here, Sargent conflated the types of subject matter that most fascinated him on Majorca—tapestry-like images of indigenous plants and glimpses of local people engaged in age-old activities such as picking fruit or tending animals. In the lower left corner of the canvas, two young girls are intent on filling their baskets with figs. To emphasize overall surface patterning, Sargent has suppressed the human element of the composition, confining the girls in a cramped, cut-off manner recalling similar figures in his *Ilex Wood at Majorca with Blue Pigs* (1908, Mitchell Museum at Cedarhurst, Mt. Vernon, Illinois).

With its distinctive Mediterranean palette and tactile surfaces, Sargent's independent body of work from Majorca stands as his most abstract painting up until then. Topically, however, *Gathering Blossoms* resonates with much earlier images of children in gardens, such as *Carnation, Lily, Lily, Rose* (1885–86, Tate Britain, London). Moreover, Sargent revisited some of these patterned surfaces as backgrounds for his Boston Public Library mural project, particularly *The Messianic Era* (1908–12). The cropped edges, overhead viewpoint, and compressed picture plane in *Gathering Blossoms* also relate to Sargent's dramatic foreshortening of contorted figures in the Boston murals.

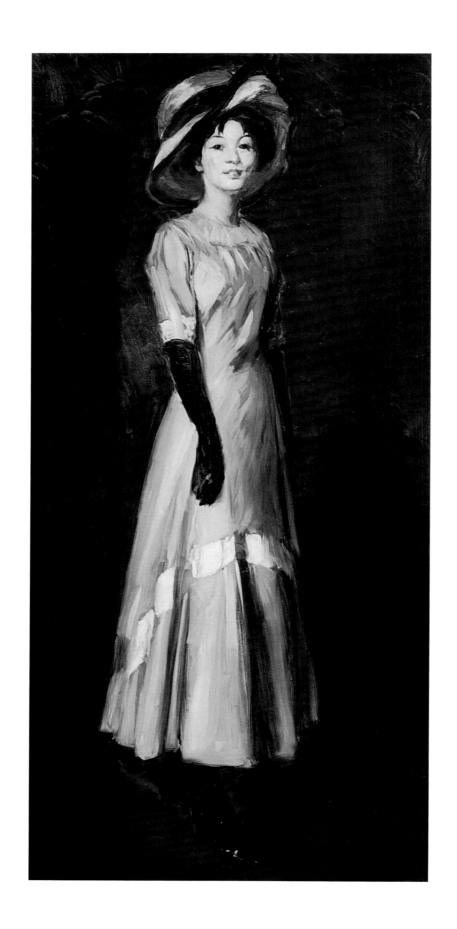

Robert Henri

b. Cincinnati, Ohio, 24 June 1865
d. New York, New York, 12 July 1929

MISS KAJI WAKI, 1909
Oil on canvas
77 x 37 in. (195.6 x 94 cm)
Signed: "Robert Henri" lower right corner

Robert Henri's unconventional upbringing—his father was a professional gambler and speculator—produced a spirited romantic with an egalitarian sense of individuality. These traits later served him well as an accomplished painter and an influential teacher who challenged traditionalism in the arts, setting the stage for American Realism and subsequent modernist art movements in the United States. Born Robert Henry Cozad, he was only a teenager when his father fled to Atlantic City with his family to avoid charges of manslaughter in Denver. Emerging with the new surname "Henri" (which he pronounced "Hen-rye"), the young Robert soon began a decade of art training and travel that took him back and forth between Philadelphia and various European capitals, particularly Paris and Madrid.

In 1908 he and his colleagues, together dubbed "The Eight," bypassed the National Academy of Design to mount an independent exhibition at the Macbeth Gallery in New York. By this time Henri was fully vested in the idea of painting as a vital democratic art form, to be expressed with a broadly brushed, straightforward technique derived from Frans Hals, Diego Velázquez, and Edouard Manet. Practicing what he preached, Henri opened his own school in New York in 1909, the year he painted *Miss Kaji Waki.*

As confident as any establishment grande dame, this well-dressed young Asian model occupies a pictorial format once reserved for official full-length society portraits. Captured in Henri's vigorous strokes, her costume is up to the minute. She wears a graceful tunic of sheer fabric with a bright green jewel neck, bordered with white at elbow and uneven hemline. Under the tunic a sea-foam green day dress with a square neck and slashed elbow-length sleeves shows through. A rather daringly raised ankle-length skirt reminds us that, in the wake of the Gibson Girl and the New Woman, independent-minded females of the early twentieth century enjoyed ever greater freedoms—not only of dress, but also of movement and occupation. Black gloves and patent medium-heel shoes complete the ensemble. Suggesting varied textures, Henri painted the shoes thickly, giving one gleaming toe a white highlight, while the black pigment depicting gloves is so thinly applied that almost-bare passages of canvas suggest the gloves are made of lace. A large hat with a wide brown band on its crown and matched edging is turned up to frame the sitter's face.

Miss Kaji Waki modeled for Henri in full-length pictures as diverse as *The Equestrian* (1909, Museum of Art, Carnegie Institute, Pittsburgh) and *Maid's Night Out* (1909, private collection). The democratic-minded Henri continued to seek out and paint everyday people of different races and ethnic backgrounds. His portraits range from Native Americans to Spanish peasants to Irish farmers. *Spanish Girl of Madrid* (1908, VMFA) reflects the impact of Velázquez on Henri. This unnamed model is as self-assured in her peasant costume as Miss Kaji Waki is wearing the latest fashion.

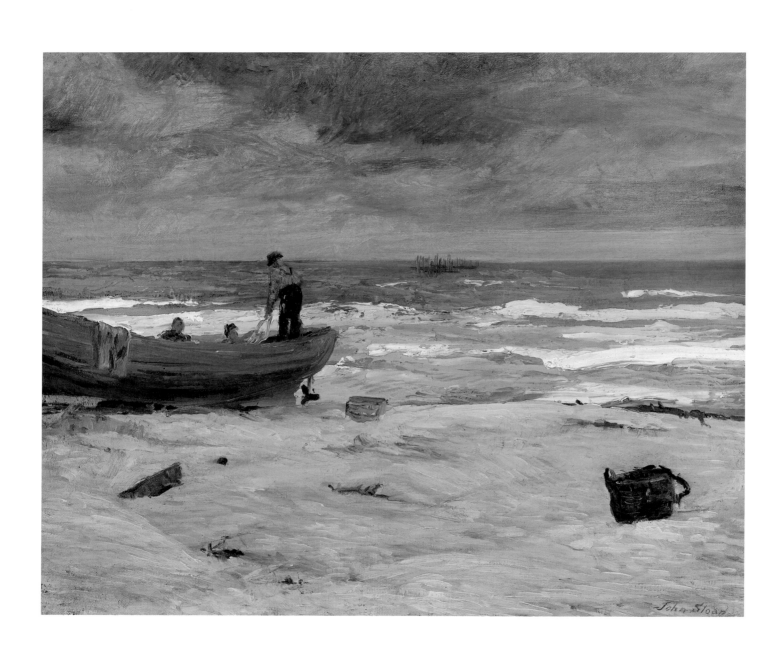

John Sloan

b. Lock Haven, Pennsylvania, 2 August 1871
d. Hanover, New Hampshire, 7 September 1951

GRAY DAY, JERSEY COAST, 1911
Oil on canvas
22 x 26 1/4 in. (56 x 66.6 cm)
Signed: "John Sloan" lower right corner

Gray Day, Jersey Coast is an unexpected topic for an artist closely associated with urban realist scenes such as *Stein at Studio Window, Sixth Avenue* (1918, VMFA), which shows a favorite model looking out over a noisy neighborhood in lower Manhattan. But Sloan was apparently happy with this somber seascape, writing in his diary about "a rather large [canvas] of the sea, gray day, which seems right interesting for a first attempt at such a subject." Neatly divided into horizontal bands of beach, sea, and sky, Sloan's monochromatic view of the coast at Belmar was painted using premixed tubes of pigment. Following set color formulas, Hardesty Maratta's commercially produced oils were developed to help American artists respond to the formal challenges of European abstraction. According to Helen Farr Sloan, the artist's second wife, it was Robert Henri who introduced Sloan to the Maratta pigments. She also identified the figure standing in the boat as Stuart Davis (1894–1964), an American modernist whose jazzy abstract canvas, *Little Giant Still Life* (1950), was one of the most controversial pictures ever acquired by VMFA.

In a subsequent diary entry, Sloan clarified that what might seem to be a fishing scene is, in truth, a salvage operation: "Stuart and I worked like heroes and got two or three long keel bolts, solid copper, also some smaller copper spikes, bruised and banged up my tender feet and hands but I enjoyed this salvage very much." Sloan's otherwise blank foreground gives us a sense of flotsam and jetsam flung up by the powerful tide. A weathered plank is half buried in the sand, and a derelict wicker basket, similar to those portrayed in Winslow Homer's fishing scenes of the 1880s, lies abandoned in the right-hand corner, its frayed rim and worn handles exposed to the elements. Conjured with thick impasto, churning white surf gives way to a chilly open sea and thinly painted, lowering sky.

A few years later, Sloan rented a summer cottage in Gloucester, the Massachusetts coastal fishing town that had gradually become a popular artists' colony (see p. 43). There, he experimented with bold, saturated color, and for the first time he concentrated on portraying nature without any figures. In works like *Blond Rock and Blue Sea* (1914, private collection) he emphasized formal properties of color, light, and composition, writing, "Instead of imitating the colors in nature, I decided on some quality of color that interested me and set a limited palette." Although he was taking a new approach to color, again using Maratta's pigments, Sloan's seascapes maintained the general tonal integrity first seen in *Gray Day, Jersey Coast*—a canvas that reminds us how younger artists' respect for Winslow Homer's dramatic seascapes of the 1890s, painted at Prout's Neck, were as important as their aspirations toward European abstraction.

Adolph Alexander Weinman

b. Karlsruhe, Germany, 11 December 1870
d. New York, New York, 10 August 1952

RISING DAY, after 1914
Bronze, cast, and patinated
Height: 25 ½ in. (64.8 cm)
Inscribed: "© A.A. Weinman.Fecit" on base
"No. 23" "W" on underside of base
"HBW" in white paint, on underside of base

DESCENDING NIGHT, after 1914
Bronze, cast, and patinated
Height: 25 ½ in. (64.8 cm)
Inscribed: "© A.A. Weinman.Fecit" on base
"No. 29" "W" on underside of base
"HBW" in white paint, on underside of base

Winged arms outstretched, Weinman's lithe *Rising Day* looks boldly up and out, lifting himself on tiptoe from a circular base embellished with a stylized blazing sun. His beautiful companion, *Descending Night,* brushes her heavy hair from her brow, letting her drooping wings begin to enclose her as she turns inward. Her curvaceous contraposto pose sinks toward a base decorated with a crescent moon and a sprinkling of stars. While the male figure is patinated in a rich chestnut brown, suggesting the coming light, the female is a darker, more muted shade evoking the advancing darkness.

Weinman conceived *Rising Day* and *Descending Night* for the Panama Pacific Exposition, a world's fair staged in San Francisco in 1915 to celebrate the opening of the Panama Canal. A colossal, now-lost version of the pair, made of reinforced white plaster, graced enormous decorated columns that were part of a fountain installed in the Court of the Universe.

Known as "the meeting place of the hemispheres," the court stood at the northern end of the fairgrounds between the Palace of Agriculture and the Palace of Transportation. It was designed by McKim, Mead, and White, a New York firm noted for classicizing Beaux-Arts architecture during the American Renaissance Revival. Appropriately, Weinman's figures restated a Renaissance theme embodied in Michelangelo's famed marble allegories of *Day* and *Night* (1526–33) on the tomb of Giuliano de' Medici in the New Sacristy of San Lorenzo in Florence, Italy.

In 1914 Weinman made 55-inch working models for his monumental plaster figures. Four sets, cast from the models by the Roman Bronze Works in New York, are known. Better scaled for domestic interiors are pairs of the bronze figures half that size. Bronze sculptures are often numbered, but how many of Weinman's parlor-size figures were cast is unclear. In this particular instance, *Descending Night* is marked "No. 29" on the underside of its base, suggesting that quite a few sets of these elegant figures might have existed. Another example at this size, now in a private collection, has a green patina, indicating that other colors were used; it bears the stamp of the Roman Bronze Works. A pair marked by the Cellini Bronze Works in New York is also recorded.

Like the bronze reduction of Augustus Saint-Gaudens's *Diana* (1899, VMFA), based on a colossal nude created for Stanford White's Madison Square Garden, Weinman's allegories brought public sculpture indoors, evidence that the Renaissance Revival stimulated not only civic pride but also domestic taste.

Robert Henri

b. Cincinnatti, Ohio, 24 June 1865
d. New York, New York, 12 July 1929

THE SKETCHERS, 1918
Pastel on paper
12 3/8 x 19 1/2 in. (31.4 x 49.5 cm)
Signed: "R. Henri" lower right corner

As art about art, *The Sketchers* lives up to its title on multiple levels. During his third and final visit to Monhegan Island, a rugged outcropping twelve miles off the coast of Maine, Henri depicted his second wife Marjorie and a mutual friend (identified in his records only as "Ruth J.") perched on a rock in a forest clearing. Light filters through the pines, glancing off the women as well as their canvases and supplies. Observing them absorbed in their work, Henri became a sketcher himself, covering his own sheet with jewel-like passages of chalk set down in rapid, minimally blended strokes. Fresh blues and greens sparked with yellows, pink, and rust stand out against darker areas of taupe, brown, black, and midnight blue. Henri's brilliant palette reflects the impact of high-keyed European pictures exhibited at the Armory Show in 1913, yet his color choices perfectly distill the bracing atmosphere of the deep northern woods.

Henri loved Monhegan Island, calling it a "wonderful place to paint—so much in so small a place one can hardly believe it." Only one mile wide by two miles long, the island is a place of virgin forests, granite boulders, rough paths, steep climbs, and spectacular views. Starting with the arrival of Aaron Draper Shattuck in 1858, Monhegan has attracted proponents of every major movement in American art. While the dramatic headlands and open ocean are most frequently depicted, Henri—whose earlier visits occurred in 1903 and 1911—was particularly attracted to shadowy forest areas such as Cathedral Woods. Back in New York, Henri exhibited *The Sketchers* in the late fall of 1918 at the Milch Gallery. He also sent a number of related Monhegan forest images to an exhibition at The Pennsylvania Academy of the Fine Arts two years later.

Discussing the appeal of sketching in his book, *The Art Spirit* (1923), Henri wrote:

> People say, "It is only a sketch," [but] it takes the genius of a real artist to make a good sketch . . . to represent air and light and to do it all with such simple shorthand means. One must have wit to make a sketch. Pictures that have had months of labor expended on them may be more incomplete than a sketch.

As this satisfying and beautifully executed pastel makes clear, Henri knew what he was talking about.

Robert Henri

b. Cincinnati, Ohio, 24 June 1865
d. New York, New York, 12 July 1929

LISTENING BOY, 1924
Oil on canvas
24 x 20 in. (61 x 50.8 cm)
Signed: "Robert Henri" lower right
Signed and inscribed verso: "Robert Henri 181/M
Listening Boy"

In his influential book, *The Art Spirit* (1923), Henri urged his students, "Feel the dignity of a child. Do not feel superior . . . for you are not." Elsewhere he tartly observed that children "have not yet been buried under the masses of little habits, conventions, and details which burden most grown-ups." A highly respected painter as well as a teacher and art theorist, Henri took his own advice to heart in capturing the sometimes bold, sometimes shy expressions of his young sitters. In 1924, Henri returned to Achill Island, Ireland, a spot that first attracted him in 1914. Among the children he painted on this trip was the dark-haired Thomas Cafferty. On the back of the canvas, Henri inscribed the title *Listening Boy.* In a related work from the same painting campaign, Henri depicted the impish Sarah Burke peeking out of a voluminous wool wrap. He christened the picture *Her Sunday Shawl;* it is now in the VMFA collection.

Henri kept a diary with notes on his pictures. His entry for *Listening Boy* emphasizes the choice of a strong palette featuring dark green, black, white, and orange. Cafferty's face emerges from an unarticulated field of blue violet and violet rose laid on in large flat areas. His stridently colored muffler is a tangle of broad paint strokes, set against the red-orange expanse of the sweater. Henri's intense color contrasts, rough execution, and dominant surface design recall the work of a controversial group of contemporary French painters whose experiments with vivid color and pronounced form earned them the nickname *fauves* or "wild beasts." But there is nothing alarming about Henri's innocently appealing subject. Young Cafferty's gaze is forthright, and his brightly lit face balances the clashing colors of his clothing. The absence of narrative detail leaves much room for the viewer's response.

Listening Boy was the first picture to enter the McGlothlin collection. Since then, in pursuing their collecting interests, the McGlothlins have exemplified another thought expressed by Henri:

> The question of development of the art spirit in all walks of life interests me. I mean by this, the development of individual judgment and taste. . . . If anything can be done to bring the public to a greater consciousness of the relation between art and life, of the part each person plays by exercising and developing his own personal taste and judgment . . . it would be well.

Henri's sensitive bust-length portraits of young children are among his most beloved works.

Bookshelf

GENERAL REFERENCE

Ayers, Linda, and Jane Myers. *American Paintings, Watercolors, and Drawings from the Collection of Rita and Daniel Fraad.* Exh. cat., Amon Carter Museum. Fort Worth, 1985.

Bolger, Doreen, and Nicholai Cikovsky, Jr., eds. *American Art Around 1900: Lectures in Memory of Daniel Fraad.* Washington, D.C., 1990.

Bolger, Doreen, et al. *American Pastels in the Metropolitan Museum of Art.* Exh. cat., The Metropolitan Museum of Art. New York, 1989.

Burns, Sarah. *Inventing the Modern Artist: Art and Culture in Gilded Age America.* New Haven, 1999.

Cooper, Helen A., et al. *A Private View: American Paintings from the Manoogian Collection.* Exh. cat., Yale University Art Gallery and Detroit Institute of Arts. New Haven, 1993.

Curry, David Park, with Elizabeth L. O'Leary and Susan Jensen Rawles. *American Dreams: Paintings and Decorative Arts from the Warner Collection.* Exh. cat., Virginia Museum of Fine Arts. Richmond, 1997.

Gerdts, William H. *American Impressionism.* New York, 1984.

Pilgrim, Dianne H. *American Impressionist and Realist Paintings and Drawings from the Collection of Mr. and Mrs. Raymond J. Horowitz.* Exh. cat., The Metropolitan Museum of Art. New York, 1973.

Pisano, Ronald G. *Idle Hours: Americans at Leisure, 1865–1914.* Boston, 1988.

Reed, Sue Welsh, and Carol Troyen. *Awash in Color: Homer, Sargent, and the Great American Watercolor.* Exh. cat., Museum of Fine Arts, Boston. Boston, 1993.

Robertson, Bruce. *Reckoning with Winslow Homer: His Late Paintings and Their Influence.* Exh. cat., The Cleveland Museum of Art. Cleveland, 1990.

Stebbins, Theodore E., Jr., with John Caldwell and Carol Troyen. *American Master Drawings and Watercolors: A History of Works on Paper from Colonial Times to the Present.* New York, 1976.

Trachtenberg, Alan. *The Incorporation of America: Culture and Society in the Gilded Age.* New York, 1982.

Weinberg, H. Barbara. *The Lure of Paris: Nineteenth-Century American Painters and Their French Teachers.* New York, 1991.

Weinberg, H. Barbara, Doreen Bolger, and David Park Curry. *American Impressionism and Realism: The Painting of Modern Life.* Exh. cat., The Metropolitan Museum of Art. New York, 1994.

Zurier, Rebecca, Robert Snyder, and Virginia M. Mecklenberg. *Metropolitan Lives: The Ashcan Artists and Their New York.* Exh. cat., National Museum of American Art. New York, 1995.

BELLOWS

Doezema, Marianne. *George Bellows and Urban America.* New Haven, 1992.

BLUM

Weber, Bruce. "Robert Frederick Blum (1857–1903) and His Milieu," Ph.D.diss., The City University of New York, 1985.

BUNKER

Hirschler, Erica E., David Park Curry, and Theodore E. Stebbins, Jr. *Dennis Miller Bunker: American Impressionist.* Exh. cat., Museum of Fine Arts, Boston. Boston, 1995.

CASSATT

Barter, Judith, et al. *Mary Cassatt: Modern Woman.* Exh. cat., The Art Institute of Chicago. New York, 1998.

Mathews, Nancy Mowll. *Mary Cassatt: A Life.* New Haven, 1998.

CHASE

Gallati, Barbara Dayer. *William Merritt Chase: Modern American Landscapes, 1886–1890.* Exh. cat., Brooklyn Museum of Art. New York, 2000.

Pisano, Ronald G. *A Leading Spirit in American Art: William Merritt Chase, 1849–1916.* Exh. cat., Henry Art Gallery. Seattle, 1983.

FRIESEKE

Kilmer, Nicholas. *Frederick C. Frieseke: The Evolution of an American Impressionist.* Exh. cat., Telfair Museum of Art, Savannah, Ga. Princeton, 2001.

GUY

Lubin, David M. "Guys and Dolls: Framing Femininity in Post-Civil War America." In *Picturing a Nation: Art and Social Change in Nineteenth-Century America.* New Haven and London, 1994.

HASSAM

Adelson, Warren, Jay E. Cantor, and William H. Gerdts. *Childe Hassam: Impressionist.* New York and London, 1999.

Curry, David Park. *Childe Hassam: An Island Garden Revisited.* Exh. cat., Denver Art Museum. New York and London, 1990.

Weinberg, H. Barbara. *Childe Hassam: American Impressionist.* Exh. cat., The Metropolitan Museum of Art. New Haven and London, 2004.

HEADE

Stebbins, Theodore E., Jr., with Janet L. Comey and Karen E. Quinn. *The Life and Work of Martin Johnson Heade : A Critical Analysis and Catalogue Raisonné.* New Haven, 2000.

HENRI

Henri, Robert. *The Art Spirit.* 1923. Reprint, New York, 1984.

Homer, William Innes. *Robert Henri and His Circle.* New York, 1988.

HOMER

Cikovsky, Nicolai, Jr., and Franklin Kelly, with Judith Walsh and Charles Brock. *Winslow Homer.* Exh. cat., National Gallery of Art. New Haven and London, 1995.

Cooper, Helen A. *Winslow Homer Watercolors*. Exh. cat., National Gallery of Art, Washington. New Haven and London, 1986.

Stebbins, Theodore E., Jr., and David Tatham. "Winslow Homer, Time in the Adirondacks." In *Winslow Homer: Artist and Angler* by Patricia Junker with Sarah Burns. New York, 2002.

PAXTON
Fairbrother, Trevor J., et al. *The Bostonians: Painters of an Elegant Age, 1870–1930*. Exh. cat, Museum of Fine Arts, Boston. Boston, 1986.

PRENDERGAST
Clark, Carol, Nancy Mowll Mathews, and Gwendolyn Owens. *Maurice Brazil Prendergast, Charles Prendergast: A Catalogue Raisonné*. Williamstown, Mass., 1990.

Mathews, Nancy Mowll. *Maurice Prendergast*. Exh cat., Whitney Museum of Art. New York, 1990.

ROBINSON
Johnston, Sona. *In Monet's Light: Theodore Robinson at Giverny*. Exh. cat., The Baltimore Museum of Art. Baltimore, 2004.

SARGENT
Adelson, Warren, et al. *Sargent Abroad: Figures and Landscapes*. New York, London, and Paris, 1997.

Gallati, Barbara Dayer. *Great Expectations: John Singer Sargent Painting Children*. Exh. cat., The Brooklyn Museum. New York, 2004.

Ormond, Richard, and Elaine Kilmurry. *John Singer Sargent: The Complete Paintings. Vols. 1–3*. New Haven and London, 1998, 2000, 2003.

SHINN
Wong, Janay. *Everett Shinn: The Spectacle of Life*. Exh. cat., Berry-Hill Galleries. New York, 2000.

SLOAN
Rowland, Elzea. *John Sloan's Oil Paintings: A Catalogue Raisonné*. Newark, Del., 1991.

STEWART
Quick, Michael. *American Expatriate Painters of the Late Nineteenth Century*. Exh. cat., The Dayton Art Institute. Dayton, 1976.

TWACHTMAN
Peters, Lisa. *John Henry Twachtman, An American Impressionist*. New York, 1999.

WHISTLER
Curry, David Park. *James McNeill Whistler: Uneasy Pieces*. New York, 2004.

MacDonald, Margaret F. *James McNeill Whistler: Drawings, Pastels, and Watercolours: A Catalogue Raisonné*. New Haven, 1995.

WEINMAN
Menconi, Susan E. *Uncommon Spirit: Sculpture in America, 1800–1940*. Exh. cat., Hirschl & Adler Galleries. New York, 1989.

Wilson, Richard Guy, et al. *The American Renaissance, 1876–1917*. Exh. cat., The Brooklyn Museum. New York, 1979.

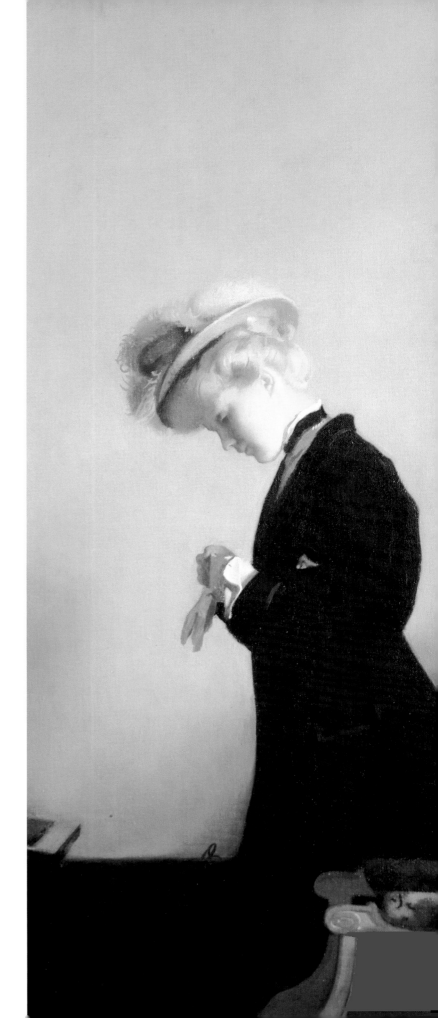

Index